VINOD CHATURVEDI

INK-LINE SKETCHING

INK-LINE SKETCHING

Paul Laseau

VNR VAN NOSTRAND REINHOLD COMPANY
New York

Copyright © 1987 by Van Nostrand Reinhold
Company Inc.
Library of Congress Catalog Card Number 86-7743
ISBN 0-442-25968-9

Printed in the United States of America
Designed by Paul Laseau

Van Nostrand Reinhold Company Inc.
115 Fifth Avenue
New York, New York 10003

Van Nostrand Reinhold Company Limited
Molly Millars Lane
Wokingham, Berkshire RG11 2PY, England

Van Nostrand Reinhold
480 La Trobe Street
Melbourne, Victoria 3000, Australia

Macmillan of Canada
Division of Canada Publishing Corporation
164 Commander Boulevard
Agincourt, Ontario M1S 3C7, Canada

16 15 14 13 12 11 10 9 8 7 6 5 4 3

Library of Congress Cataloging-in-Publication Data

Laseau, Paul, 1937–
 Ink-line sketching.

 Bibliography: p.
 Includes index.
 1. Pen drawing—Technique. 2. Dry marker
drawing—Technique. I. Title.
NC905.L33 1986 741.2'6 86-7743
ISBN 0-442-25968-9 (pbk.)

CONTENTS

PREFACE

Learning to draw with a fountain pen enables you to draw anytime, anywhere, and with little or no planning or preparation. Many people who have drawing talent and facility make drawing conditional upon time, place, equipment, and various other factors before they ever put drawing instrument to paper. They are thus limiting their pleasure and growth as an artist. If only to "think on paper," the artist must react to inspiration where and when it happens despite the inconveniences and limitations inherent in the situation. (Nick Meglin)

If we include within ink-line media a variety of fine-line markers that have capabilities similar to the fountain pen, the preceding paragraph states the case for this book on ink-line sketching. Drawing skills, like athletic skills, require constant conditioning to assure peak performance; when we fail to exercise them, we lose perception, concentration, relaxed awareness, and dexterity. Technical improvements in fountain pens and fine-line markers have made them the most effective and versatile equipment for daily "workouts" in the fundamentals of artistic and design skills. These instruments are portable, durable, accessible, easy to maintain, and reliable; with practice, the artist or designer can take advantage of the sensitivity, fluidity, precision, speed, flexibility, and economy of ink-line techniques.

This introduction to ink-line sketching incorporates strong points of view about the oneness of seeing, drawing, and thinking, the comprehensiveness of drawing subjects, and a reinforcing relationship between drawing and living.

1. Like many people who sketch extensively, I am aware that drawing has affected the way I see things and that the way I see is an important factor in the effectiveness and quality of my drawings. Similarly, what I see critically affects the way I think. It is these relationships that provide each of us with unique ways of drawing and thinking creatively. For these reasons seeing and thinking are treated in this book as an integral part of drawing technique.

2. To take full advantage of the versatility of ink-line media, we must stretch our exercises to cover a variety of subject matter. Just as exercises in composition and perspective are mutually reinforcing, the drawing of both people and architecture or flowers and machinery brings new perceptions and increased sensitivity to each subject.

3. Among those studying human potential and the quality of life, there is a growing affirmation of the importance of the reintegration of our lives. This means the dissolving of artificial barriers between work and leisure, productivity and creativity, or physical and mental activity. In this light drawing is not just a means to an end but also a healthy part of daily living. A relaxed state often accompanies deep concentration in drawing; many authors have described this as similar to meditation, which is widely advocated as a benefit to physical and mental as well as spiritual health.

In the following pages, I hope you will find some of the excitement I have derived from sketching and the encouragement you need to get started and to continue.

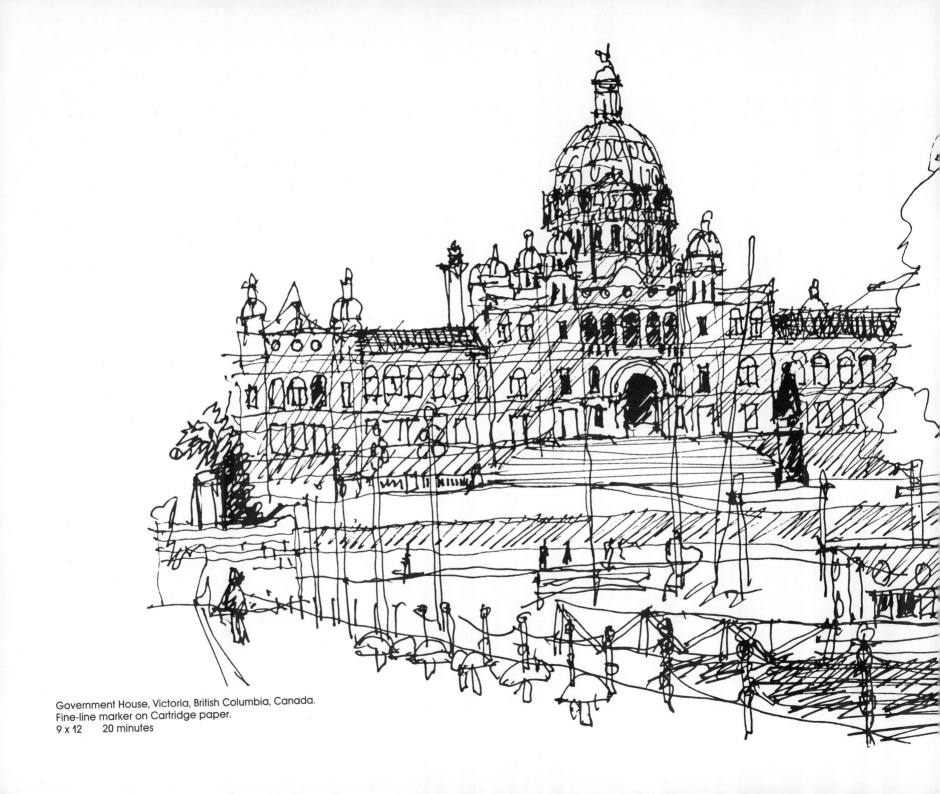

Government House, Victoria, British Columbia, Canada.
Fine-line marker on Cartridge paper.
9 x 12 20 minutes

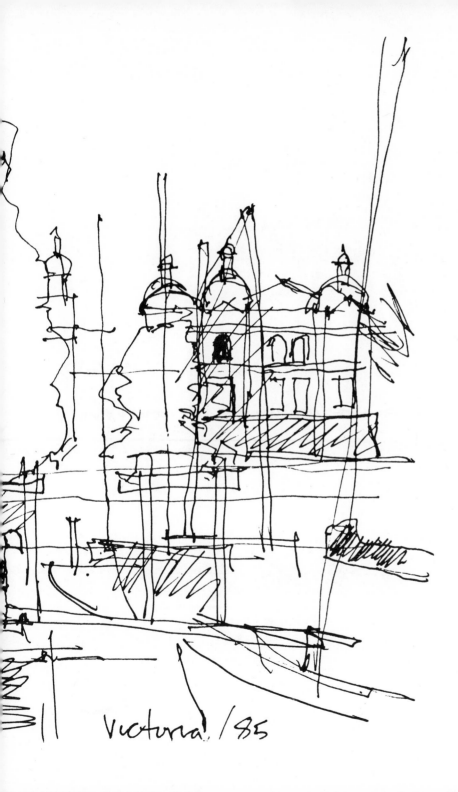

Victoria/85

1. INTRODUCTION

Have you ever wished you could draw or paint? Would your work benefit by your facility at communicating ideas graphically? Do you wish you could express your feelings or capture an experience in an image? Sketching is the quickest, most effective means I know of to develop and maintain the mind, eye, and hand skills these pursuits require. This book is aimed at developing those sketching skills.

Why start sketching with *ink line*? Of all the media I have used for teaching drawing, ink line has been the most supportive of the learning process. First, the permanence of ink encourages one always to "go for it," to try to put the line right where it should be. As you will see later, it is not usually a problem if the line lands in the wrong place, but continued attempts to place lines accurately build the eye-hand coordination necessary for sketching. With pencil there is a tendency to be timid, either using very faint lines or erasing bad lines. To learn to sketch, it is better to do a dozen poor drawings than one acceptable drawing. Second, line sketching tends to emphasize the structure of a drawing rather than the nuances of media. In ink line the variables or options are limited by the choice of size or type of pen point. By limiting the options further, through the choice of fine points that produce a uniform line regardless of which direction the pen is moved, priority is given to *seeing* rather than decorating the drawing. Sketching is a continuing source of learning rather than a string of performances.

The Experience of Sketching

For most of us, the prime reason to take up sketching is to produce admirable drawings that give us a sense of accomplishment. Although such motivation is important, narrow concern about results not only inhibits learning but also hides an even greater source of motivation—the wealth of other experiences that sketching brings. If we look carefully at the subjects we sketch, a new, exciting world of awareness and delight opens to us. The sketch of a Paris street was done while sitting on a public bench. As the sketch developed, I became aware of how the regular patterns of similar buildings become animated through the following: the influence of the unusual pattern of Paris streets; the play of light and shadow; the contrasts between the cool darkness under the café awning and the dazzling glare of the sun rebounding from the buildings in the background; and the important role of people in making a view stimulating.

Sketching is also a means of escaping from the world around us. The level of concentration is such that one can become completely absorbed in the process, losing all sense or concern for time. Finally, sketching is a physical experience to be enjoyed in itself; the feel of the paper and the movement of the pen across the surface become part of the stimulation and reward of sketching. Accomplished sketchers know that ultimately the quality of their drawings is derived from these experiences of awareness, concentration, and touch. If we fully participate in these experiences, we need not worry about the results. The sketch of the gatehouse at Montacute was done in ten minutes. I cannot tell you how it was done—the result was a complete surprise to me. What I can say is that I was completely absorbed in what I was doing and thoroughly enjoyed myself; and I think that is reflected in the drawing.

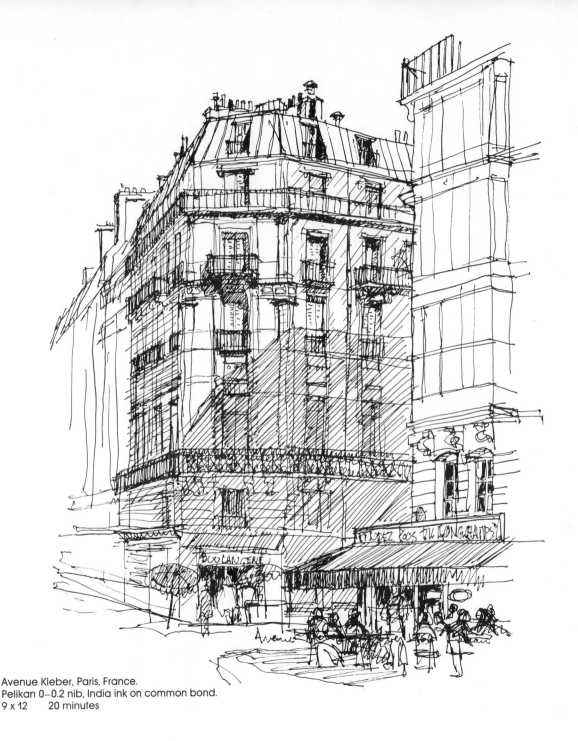

Avenue Kleber, Paris, France.
Pelikan 0–0.2 nib, India ink on common bond.
9 x 12 20 minutes

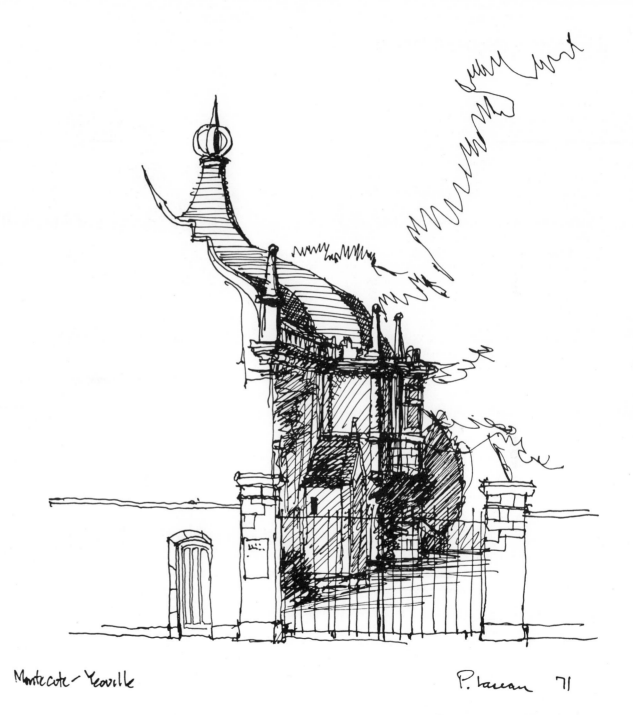

Gatehouse, Montacute, England.
Pelikan 0–0.2 nib, India ink on common bond.
9 x 12 10 minutes

Montacute–Yeovill

P. Laseau 71

Learning to Sketch

Drawing is not easy; in fact it is hard work. Do not worry if you do many drawings that prove disappointing, or even some that go wildly wrong. If you are using your mind, and your powers of observation, as you draw, you will have learnt *something* whatever the result. Enjoy what you are doing. If things go wrong you can always start again the next day. (Downer 1962, p. 7)

Attitude is the most important tool for learning to sketch. From my experience and that of many other writers and teachers, I can attest that, barring a physical impairment, anyone can learn to sketch. Can you become expert at sketching? Possibly, given time; remember the experts bring a lifetime of experience to each sketch. Can you become effective at sketching? Definitely. Will sketching be worth the time you invest in it? I can guarantee it!

Place des Vosges, Paris, France.
Fountain pen, permanent black ink on onionskin.
5 x 7 15 minutes

Bath, England.
Pelikan 0–0.2 nib, India ink on common bond.
8 x 10 15 minutes

Shaftsbury, England.
Osmiroid Extra Fine nib on Pentalic paper for pens.
9 x 12 15 minutes

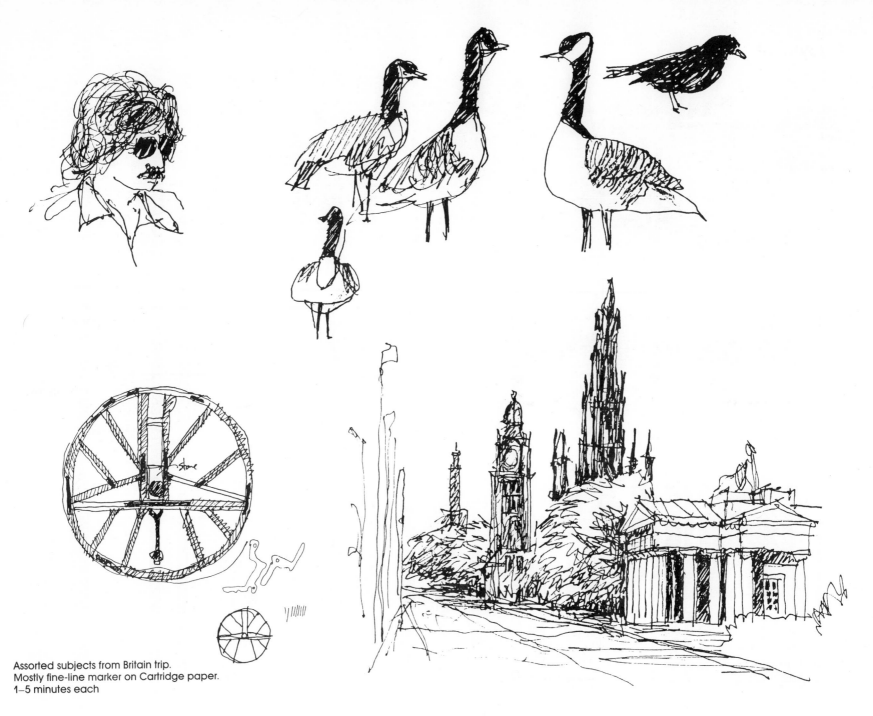

Assorted subjects from Britain trip.
Mostly fine-line marker on Cartridge paper.
1–5 minutes each

Enjoyment

If you enjoy looking at drawings, sketches, or paintings, you will almost surely enjoy sketching. Remember that you are sketching for your own enjoyment and not for someone else or for some other goal. We are often hard on ourselves, feeling that we can not afford the time to indulge in something that does not have immediate practical, even financial, rewards. To see ourselves as purely functional or economic beings is to cut ourselves off from much of life. If you open yourself to it, sketching can be an immensely rewarding pursuit, an enriching view not only of the world and people around you, but also an insight into your own perceptions of that world. The sketches on these pages were made on a trip around Britain. Each occasion provided a unique learning experience, and when I look at them now, I continue to learn.

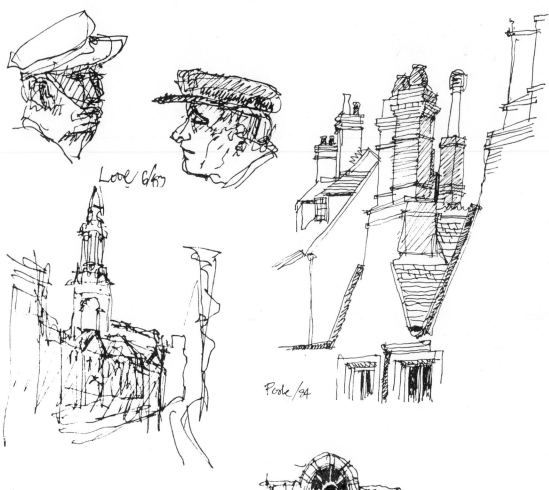

Assorted subjects from Britain trip.
Mostly fine-line marker on Cartridge paper.
1–5 minutes each

2. EQUIPMENT

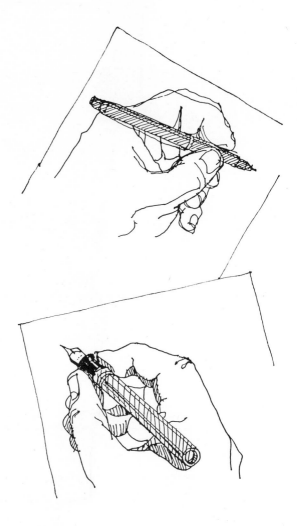

The key to learning to sketch is to do it and to do it often. This means that you must be ready to sketch anytime, anywhere. Fortunately the basic equipment for ink-line sketching is very simple—a fine-line ink pen or marker and a pocket-sized pad of paper. Their principal virtue is portability, allowing you to take advantage of any opportunity to sketch.

Considerations

All other equipment needs are extensions of these basic tools. The following suggestions address needs you may develop for variations in the scale and visibility of sketches as well as the durability, utility, and compatibility of the equipment.

Scale: As interest and skills develop, there will usually be a need for paper that is larger than pocket size. In order not to inhibit spontaneity or regularity of sketching, you will have to develop methods or habits that assure that paper is always on hand. Some people keep similar pads in several locations—around the house, at work, in a briefcase or a bag. Others use whatever loose sheets of paper are at hand and periodically collect them in a folder.

Visibility: Generally, to be effective, sketches should be easy to see. Black ink produces clear, high-contrast images. Ink seems to work best on smoothly finished papers. Paper that is too porous will spread ink or snag the point of the pen, resulting in fuzzy, irregular lines. Paper that is too thin may tear or let ink bleed through to the next page.

Durability: Equipment should be capable of producing a permanent record. Pens should have stable, permanent inks. Although fine-line markers are very convenient for sketching, the images they produce on paper deteriorate, in varying degrees, over time. For durability I suggest permanent, jet-black fountain pen ink. Points on most pens or markers will eventually wear down until they are no longer useful. You may want to use one of the pens with more durable points, but their high cost, and one's fear of losing them, may be counterproductive. Paper must be durable enough to survive the effects of continuous use and long storage. Pads should contain good-quality paper protected by a heavy cover that is not easily bent or torn.

Utility: If a piece of equipment is difficult to use, you will probably avoid using it, thus defeating its purpose. Pens that leak in your pocket, run out of ink, or dry out are a nuisance and discouraging. The cartridge-refill ink pen is one convenient solution for these problems. Another annoyance may be notebooks that are too thick or too large to hold or carry. A spiral binding can be helpful because the rigid cover and used pages can be turned completely back, making the notebook much easier to hold.

Compatibility: If you find after a while that any of the suggestions above or in the rest of this chapter get in the way of your enjoyment of sketching, abandon them at once. If you get a kick out of drawing with a fat marker on paper towels and that leads you to do more sketching, do not hesitate. It is difficult to predict what will motivate different people. Some of you may be more comfortable with a certain color of ink or paper. Others may like the feel of a particular pen or paper. Experiment! That is another dimension of the enjoyment of sketching.

Pens

Many brands of fine-line markers produce a clear, dark line and are convenient to carry. The cartridge-ink pen is a good option for people who prefer a fluid line; it has the added advantage of being less susceptible than markers to blotching or bleeding through the paper. Broad-tip markers are not very practical for sketches, because they are difficult to control and bleed through the paper even more than fine-line markers.

You may wish to carry a variety of pens or backup pens and cartridge refills with you, or you may simply want to safeguard against wearing holes in your pockets or causing ink stains on your clothes. Some people carry sketching equipment in a camera bag or attaché case. A less cumbersome option is a container, such as a soft eyeglass or pencil case, which can easily be carried in a jacket pocket and protects the pens and pencils as well as your clothing. I use a leather cigar holder.

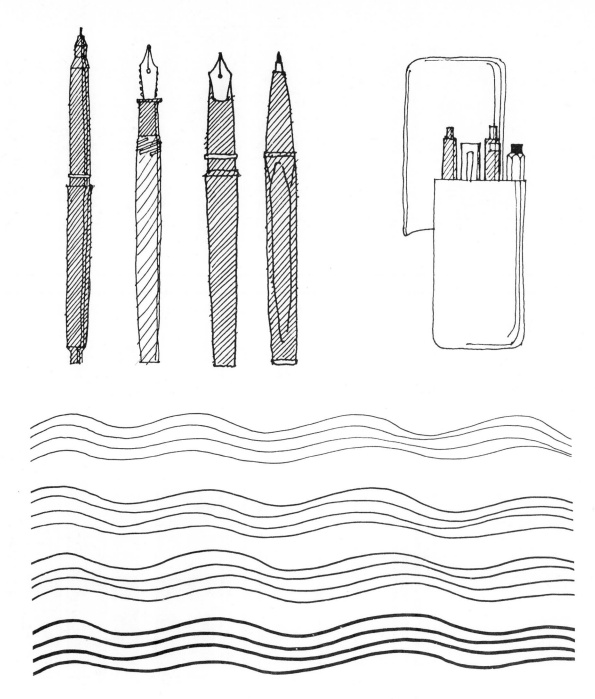

a word to the wise

pen

Fountain pen with cartridge refill.

Broad-tip marker.

Paper

Of the variety of sketchbooks available, two basic types seem to be most effective for everyday sketching. The first, bound with a wire spiral at the top or the side, is about 3½ inches wide, 5 to 6 inches high, and about ½ inch thick, with a stiff cardboard back cover. The second type of sketchbook is stitch-bound with a stiff cover and is about the same size as the spiral bound sketchbook but not quite as thick. Other options include a removable protective cover into which soft-cover notebooks can be inserted or a rigid-back cover with a soft front cover that can be folded over the top of the pad.

Sketchbooks are manufactured with a variety of papers. Many of the all-purpose sketch papers made in this country are intended for both pencil and pen, and tend to be too rough or porous for pen. I recommend a highly opaque paper with a smooth finish; this should allow you to make crisp drawings that do not show through to the other side of the page. Cartridge paper, common in Britain, is excellent; in United States Strathmore 400 series drawing paper and Bienfang graphics 360 are probably the best of the papers commonly available in pads. If you have difficulty finding the right sketchbook, consider having your choice of paper bound to your liking; it is a surprisingly easy and inexpensive process. Another option is to secure loose sheets of paper to a stiff piece of cardboard with spring clips. To protect the paper, cut the cardboard slightly larger than the paper size. In loose sheet paper, I recommend 1-ply bristol board made by Strathmore. Once you have developed some degree of confidence in your sketching, you should experiment with different papers and sketchbooks to find ones that suit your way of working.

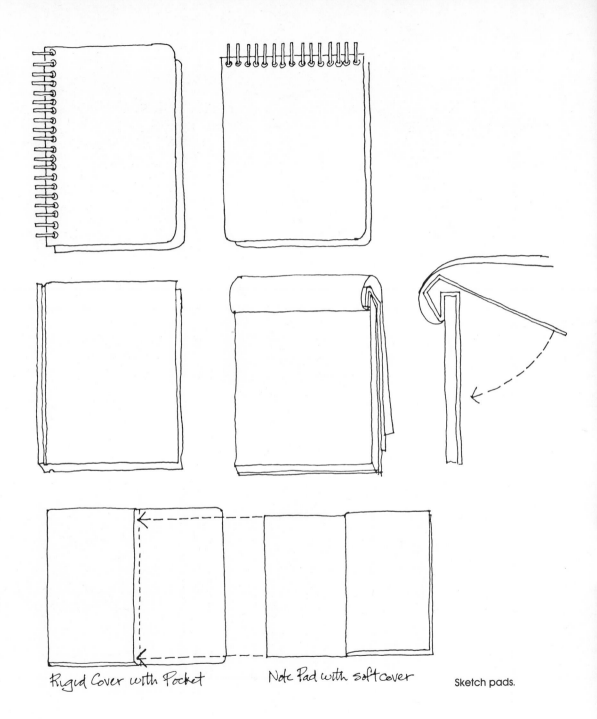

Rigid Cover with Pocket

Note Pad with soft cover

Sketch pads.

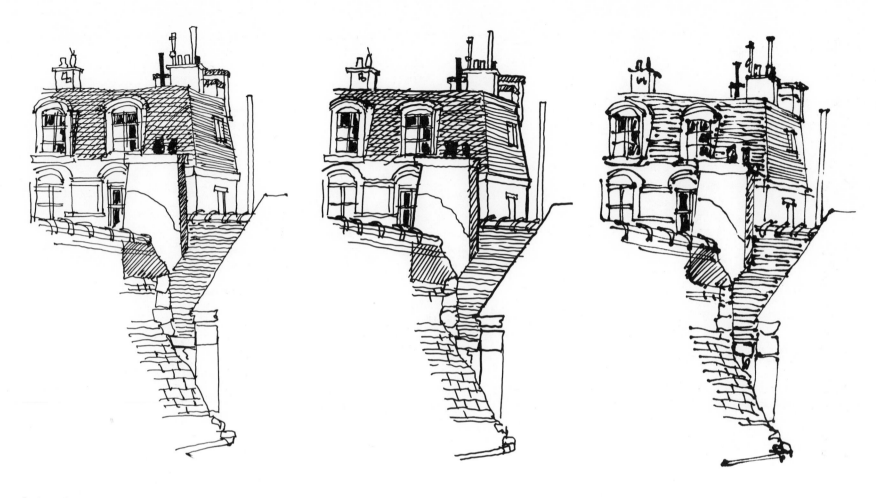

Paris rooftops.

Osmiroid Rolatip, extra fine on 1-ply bristol board.
3 x 5 10 minutes

Pentel Sign Pen on 1-ply bristol board.
3 x 5 10 minutes

Fine-tip fountain pen on ink blotter.
3 x 5 10 minutes

Other Equipment

For working outdoors, sketching trips, or extended travel, you may want to get a little more organized. I have found an airline bag with multiple pockets and a shoulder strap to be particularly well suited. Choose a bag that accepts your largest pads in a pocket separate from pens, ink, or anything else that might damage the paper. There should be enough room for other travel equipment—a camera or bottle opener as well as materials for other media you may try. Getting everything in one bag simplifies handling equipment and reduces the chances of losing items. To further protect equipment or keep it dry, use reclosable plastic bags such as Ziploc; they are durable and come in a variety of sizes, including ones large enough to hold 9 x 12-inch sketchpads.

A small 35-millimeter camera with automatic shutter is very useful for recording details or color when time on-site is limited. However, overdependence on photography can drain your drawings of spontaneity and economy as a result of overworking them at a later time. I also find a small microcassette recorder handy for putting in words my reactions to a sketching subject; this helps me get in the right mood to make finishing touches on the sketch later.

For the occasional ink wash or watercolor, I carry water in a 12-ounce jelly jar with a tight-seal top and a roll of paper towels for cleaning brushes and quickly minimizing the damage of inevitable accidents. Depending on time and other circumstances in which you sketch, other handy equipment may include binder clips to hold back sketchbook pages, a couple of sheets of ink blotter, paper towels, a thin plastic 6-inch ruler, a small glue stick, and a portable stool.

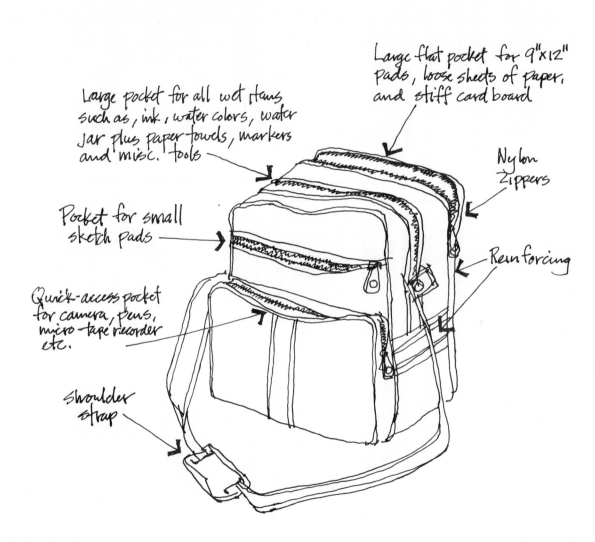

Large pocket for all wet items such as, ink, water colors, water jar plus paper towels, markers and misc. tools

Large flat pocket for 9"x12" pads, loose sheets of paper, and stiff card board

Nylon zippers

Pocket for small sketch pads

Reinforcing

Quick-access pocket for camera, pens, micro-tape recorder etc.

shoulder strap

Travel sketch bag.

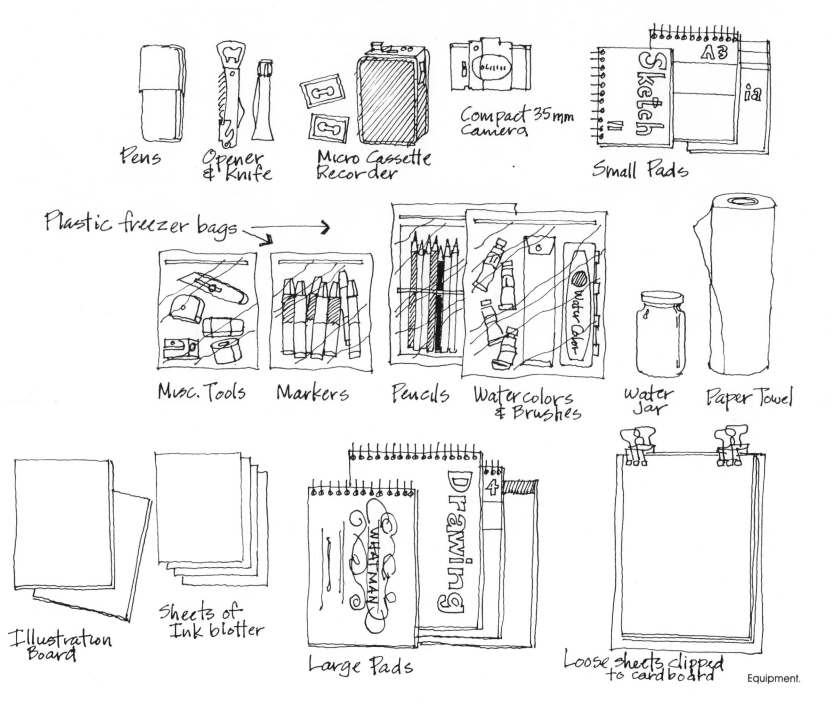

Pens

Opener & Knife

Micro Cassette Recorder

Compact 35mm Camera

Sketch A3 ia

Small Pads

Plastic freezer bags →

Misc. Tools

Markers

Pencils

Water Color

Watercolors & Brushes

Water Jar

Paper Towel

Illustration Board

Sheets of Ink blotter

WHATMAN

Drawing

4

Large Pads

Loose sheets clipped to cardboard

Equipment.

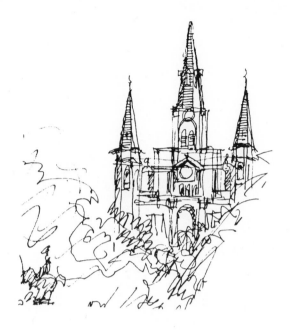

3. LEARNING TO SEE

Drawing is a curious process, so intertwined with seeing that the two can hardly be separated. Ability to draw depends on ability to see the way an artist sees, and this kind of seeing can marvelously enrich your life. (Edwards 1979, p. 2)

Seeing what you never could see before is the unexpected bonus of drawing; it is also the key to development of drawing skills. Sketching on a regular basis provides the opportunity to practice seeing. To take advantage of the opportunity, it is helpful to take on a new awareness of the visual world around us. The illustrations on this page are portions of larger sketches, some of which appear elsewhere in this book. In each instance, I had to look closely at the subject in order to draw it. As a result I became aware of something special: the way a wineglass reflects light, the patterns of a building facade, the peculiar configuration of a specific type of tree, and the components of a jeep. I will never look at these subjects in quite the same way again.

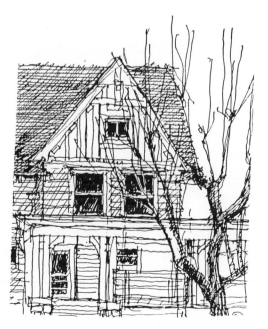

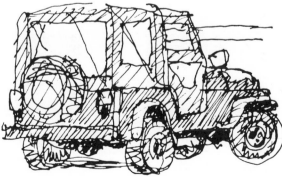

Awareness/Receptivity

Because seeing and drawing are so inter-
dependent, it is difficult to learn to see before
beginning to draw. Drawing is the key to effective
seeing, and seeing is the key to effective drawing.
Where do we start? The drawing/seeing process is
like a motor that needs a start. We need to use
an electric starter to turn the motor a few times
before it can run on its own. The starter is
motivation; if we can derive initial interest or
enjoyment from first efforts to draw, we will begin
to see. This will lead to an improvement in our
drawings and increased motivation.

The first and most important thing about drawing . . . is to
realize that what you intend to draw should interest you
as a subject. It should be something that excites you
when you look at it, something that has plenty of interest
in the way of shapes and textures. . . . (Downer 1962, p. 9)

While this may seem the most obvious of
principles, it is the most ignored or violated in
classrooms and books. You might start with
subjects in which you have a special interest:
objects you collect, tools you use, your favorite
chair or room. Most of us are so conditioned in
our habits of observation that we miss interesting
subjects for sketching. Plants, flowers, food, a can
of pencils, bottles, or books can provide
interesting compositions of color, texture, and
detail.

Household objects.
Fine-line marker on Cartridge paper.
2–10 minutes each

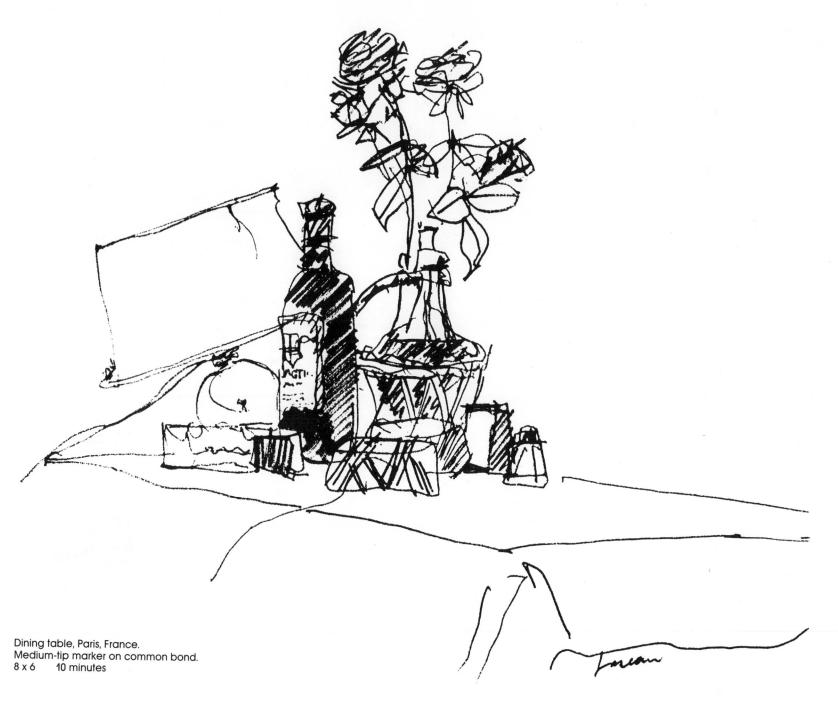

Dining table, Paris, France.
Medium-tip marker on common bond.
8 x 6 10 minutes

You may be more stimulated by unfamiliar subjects. Travel provides a rich source of material for sketching. If you allow the time to stop, look, and sketch, you will not only find plenty of subjects, but also get much more out of traveling. Sketching is often a good way to meet local people, particularly when you do not speak their language. Many people are drawn to you out of curiosity and often display a genuine interest and appreciation of your work. But they are not always sympathetic to being included in your sketch themselves. You should either try to be carefully inconspicuous or approach them directly and ask for their permission or cooperation.

Try to incorporate sketching with other enjoyable experiences of traveling. Some of my best sketches have been done while sitting in an open-air café or soaking up the sun on a park bench. Relax, spend some time just looking at the scene around you. A good sketch is often the result of a special perception or motivation derived from the overall context or occasion in which it is made.

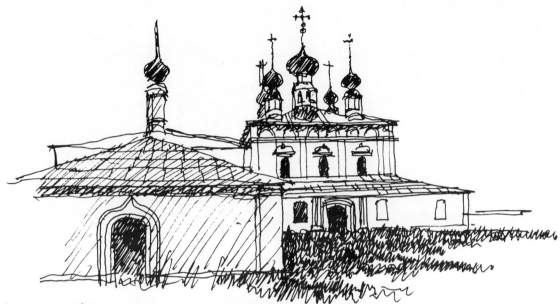

Russian monastery.
Fine-line marker on Strathmore 400 series drawing paper.
4 x 7 20 minutes

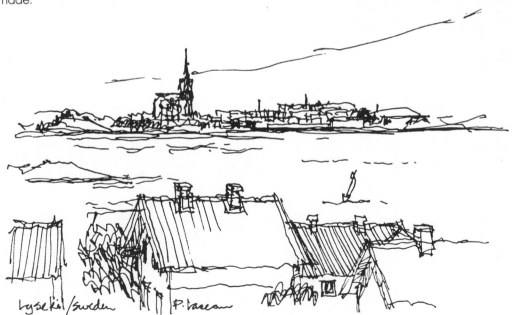

Lysekil, Sweden.
Fountain pen on Cartridge paper.
4 x 6 10 minutes

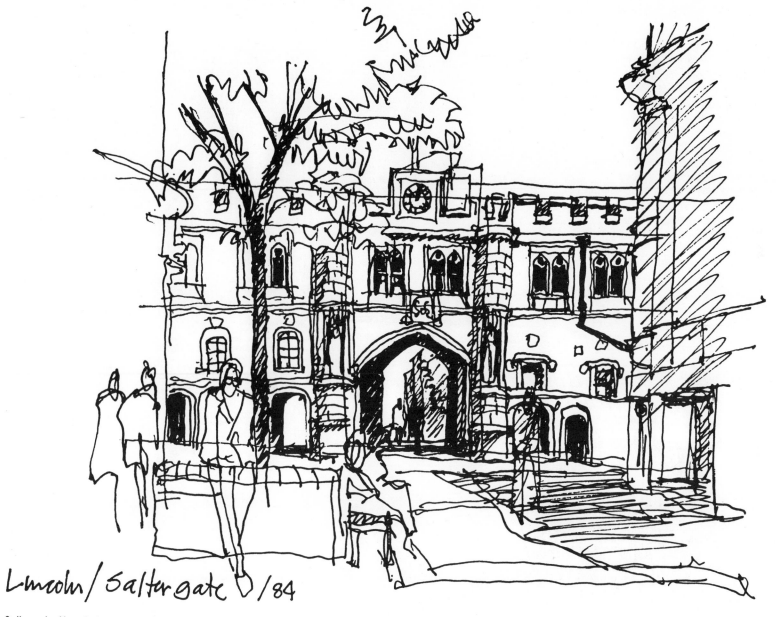

Lincoln/Saltergate ◊/84

Saltergate, Lincoln town center, England.
Fine-line marker on Cartridge paper.
4 x 6 25 minutes

Buildings are particularly good subjects for sketching. Older houses, barns, or factories are full of interesting discoveries. Initially it is important not to set yourself a sketching task that is so difficult or time-consuming that you become discouraged and lose interest. The advantage of buildings as sketch subjects is that they have several parts such as windows, doors, chimneys, or signs that are interesting and manageable subjects.

Good sketches are the result of observation and insight. Take the time to observe your subject often. Are there dominant colors or shapes? Which objects move or change over time? What patterns are created by shadows? How many different types of clothes do people wear?

Grain depot, Indiana.
Fine-line marker on common bond.
8 x 10 10 minutes

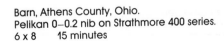

Barn, Athens County, Ohio.
Pelikan 0—0.2 nib on Strathmore 400 series.
6 x 8 15 minutes

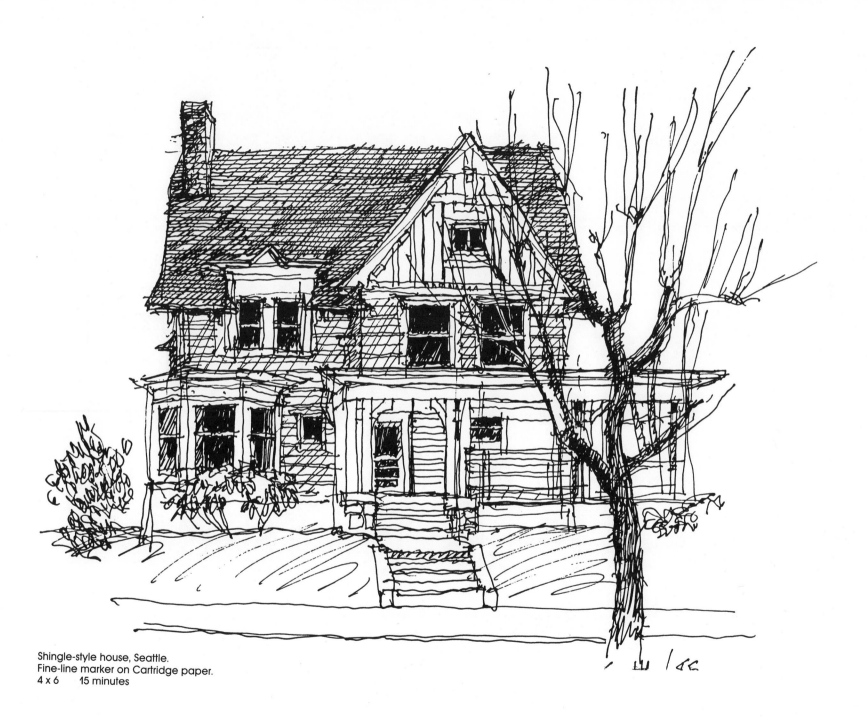

Shingle-style house, Seattle.
Fine-line marker on Cartridge paper.
4 x 6 15 minutes

Learning about the Sketch Subject

Sketching is a human process, involving the mind as well as the hand. Knowledge, sensitivity, empathy, or fantasy concerning a subject intensifies the act of sketching it. Such understanding of a subject can be derived indirectly through conversation, reading, or research, or directly through examination and exploration of the subject itself. I have found that knowing about the wonderful history and tradition of Parisian cafés adds considerably to the joy of sketching them. I imagine the simple and profound pleasures of life being absorbed by friends, lovers, and strangers, the reunions, the intrigues in the soft shadows below the red awning. I recall the sparkle of sunlight dancing over and through wineglasses, bottles, pâté, and the soup du jour. Similarly, a knowledge of the history of the Shaker movement and an appreciation for the simplicity and directness of their way of life adds much interest to sketching their utensils and artifacts. Each subject you select provides a new opportunity to learn.

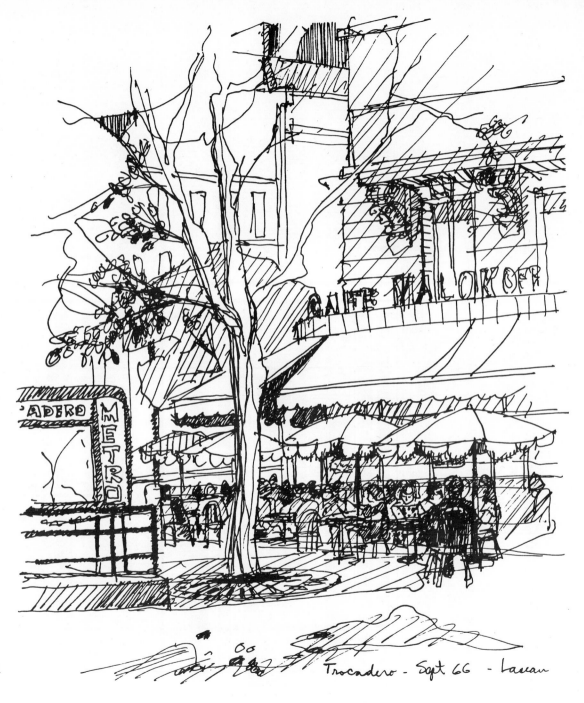

Café near Trocadero, Paris, France.
Pelikan 0–0.2 nib, India ink on common bond.
8 x 10 25 minutes

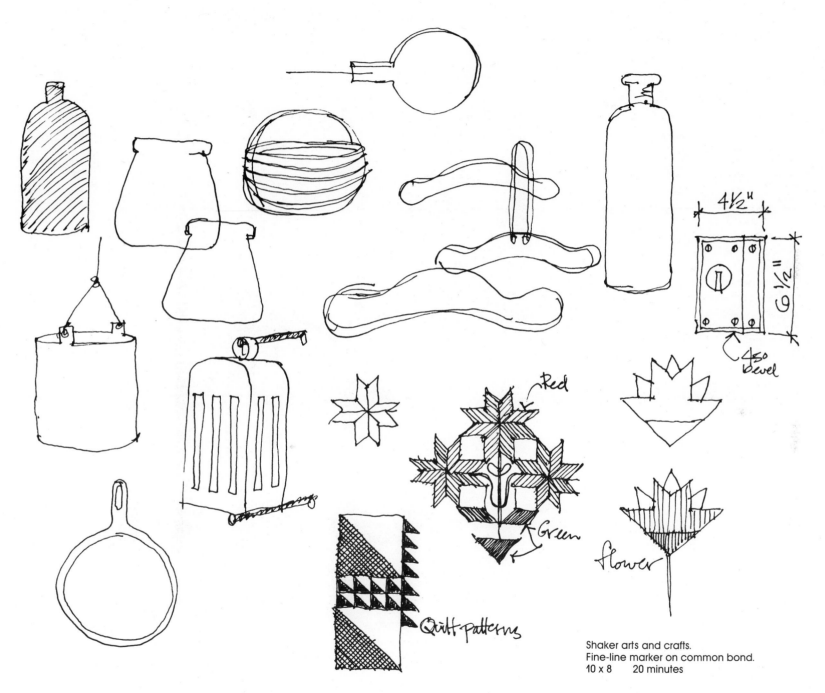

4½"

6½"

45°
bevel

Red

Green

flower

Quilt patterns

Shaker arts and crafts.
Fine-line marker on common bond.
10 x 8 20 minutes

While indirect knowledge of a subject can be very helpful to sketching, direct knowledge is essential. Each subject we encounter is a unique occurrence with special circumstances and surroundings, and each sketch is an opportunity to broaden our appreciation of a subject. Barns are much alike in their form and construction, but in the several years that I have sketched barns in a few Indiana and Ohio counties, I have constantly made discoveries that have increased my interest in barns.

If your subject is a small object, pick it up, turn it around, move it into the light, or move around it; discover its many possible appearances; feel its surface, size, and weight; view it from a distance or with other objects; finally, look carefully at its parts and details. If your subject is larger, walk around it, looking at it from different angles; make quick, tiny sketches of views that are interesting; feel the warmth or coolness and the texture of the surfaces; notice the shadows; note the changes in light. With any subject also make written notes about your observations and the thoughts they evoke. When you are drawn toward or inspired by a particular view of your subject, you are ready to sketch. At this point you need not worry about all you know about the subject. Generally, useful ideas pop up when you need them, and the feelings you have developed become immersed in the sketch itself.

Now that you are prepared to sketch, keep a few dicta in mind:

1. You are sketching for your own benefit; enjoy it!
2. Pick subjects that are interesting to *you*.
3. Seeing is the most important skill in sketching.
4. Sketch every day in any situation.

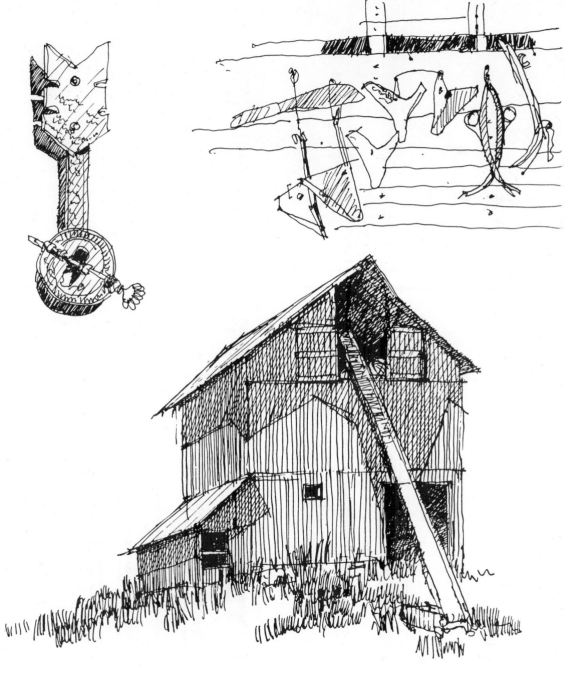

Barn and farm equipment.
Fine-line marker on common bond.
10 x 8 25 minutes

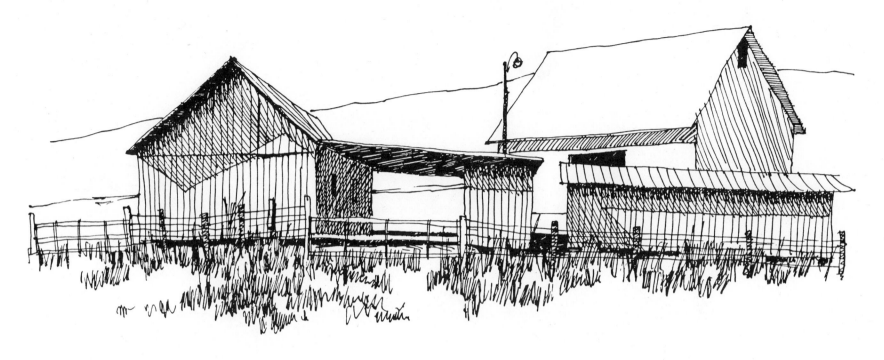

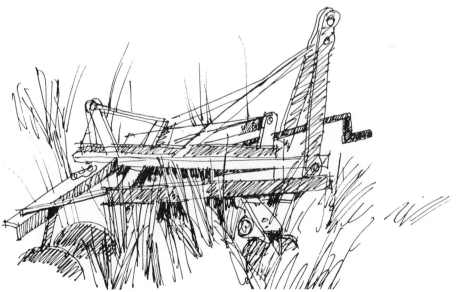

Barns and farm equipment.
Fine-line marker on common bond.
10 x 8 30 minutes

4. BUILDING A SKETCH

A common impediment to learning how to sketch is being overwhelmed by the complexity of the subject. When I first took on the task of sketching specific objects or views, I assumed I had a responsibility to draw everything. The subjects appeared too complex for a novice sketcher to undertake: "There must be thousands of leaves on that tree; how can I expect to draw all of them?" I was defeated before starting.

The solution to this dilemma is having a plan of attack, building a sketch. This approach, for which I am indebted to Richard Downer, makes any sketching task feasible by organizing it into several smaller, less threatening tasks. The sequence of the tasks is arranged to minimize the occurrence of common mistakes and to maximize effectiveness.

The three major sketching tasks are these:

composing the view; modeling space and form with tone; and indicating detail, texture, and pattern. Each of the following three chapters is devoted to one of these major tasks. As we address each task, it is important to keep in mind that all sketching tasks require a concentrated look at the subject. The objective is to draw what you actually *see*, not what you think you *know*.

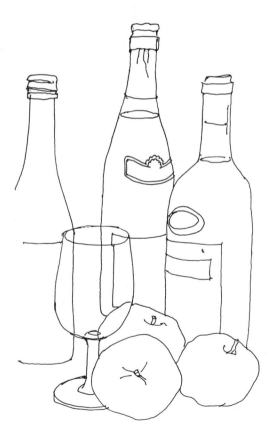

Sketch composition.

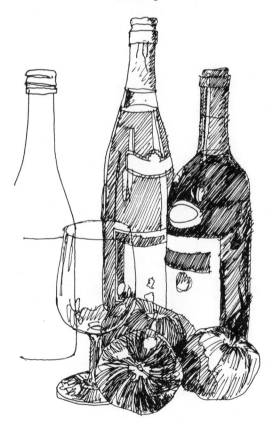

Addition of tones.

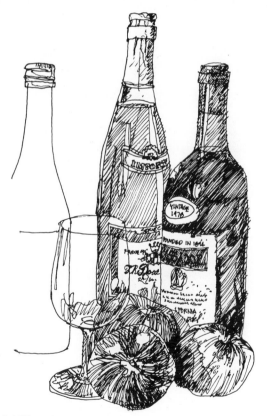

Addition of detail.

To build a drawing of a fishing village, we take three major steps. The first step is a simple, economical line drawing, in which our main concern is to show the parts of the subject in their proper scale, proportion, and position. The second step uses tone to show the shaping and distinction of forms by light. In the third step, detail information is included to help identify various elements of the sketch.

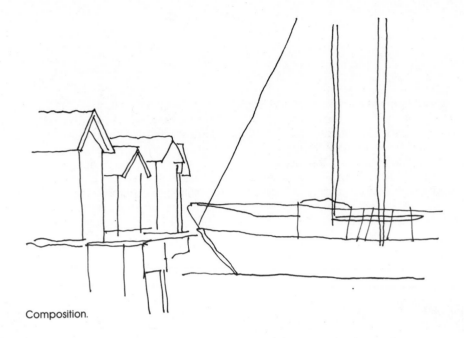

Composition.

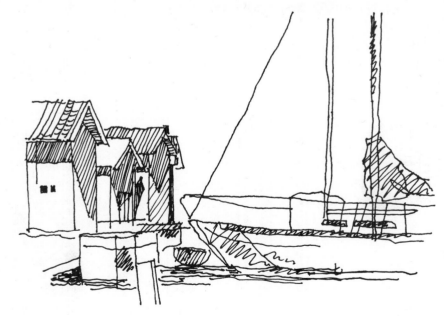

Addition of tone.

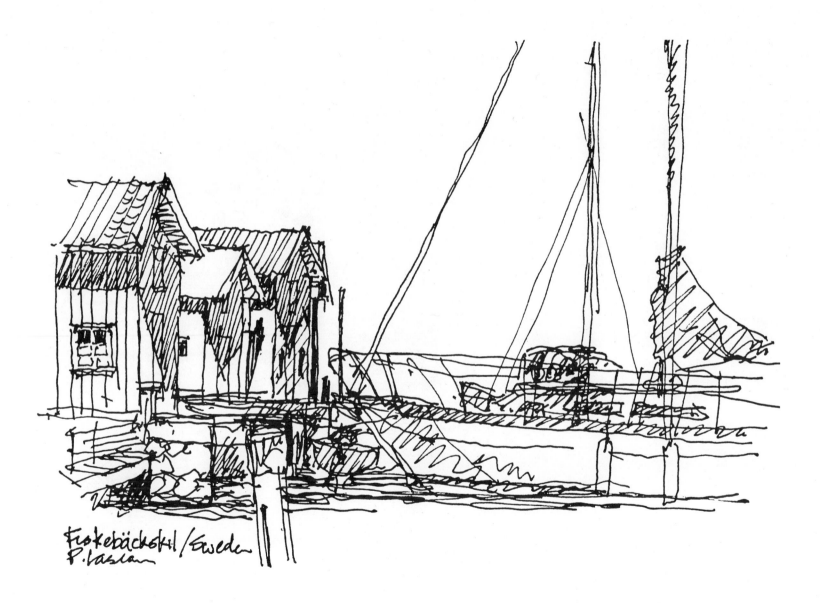

Fiskebäckskil / Sweden
P. Laslau

Addition of detail.

Sketch Composition

This task is placed first because it provides the framework for all other sketching tasks. While mistakes in indicating tones or detail may often be absorbed by a sketch, mistakes in composition, proportion, or scale often make or break a sketch. It is very difficult to build a good sketch on the foundation of a bad composition. If your first attempt is poorly composed, it is better to abandon the sketch and begin again.

Most subjects for sketching are three-dimensional. However, sketches are created on a two-dimensional surface. Most composition mistakes in sketching result from the difficulty of translating visual information from three to two dimensions. In most simplistic terms, we tend to include in the plane of our sketch distances in depth (the third dimension), of which we are aware because of stereoscopic vision. Because there is no space for them in the two-dimensional plane, the sketch must be distorted to accommodate them. The other tendency is to misjudge the scale relationship between the view of the subject and the sheet of paper on which the sketch is made. As it becomes clear that the view will not fit on the paper, sketches are often distorted as an expedient.

The key to overcoming these tendencies is first to establish the frame or limits of the view to be included in your sketch and then to concentrate on positioning the various elements accurately within the view. Alternative methods for positioning elements—composing the view—are discussed on the following pages.

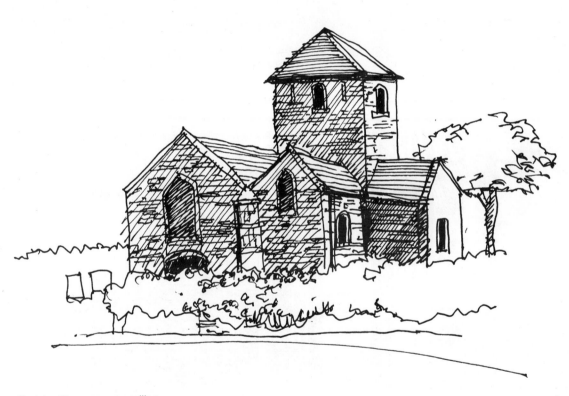

Sketch with poor composition.

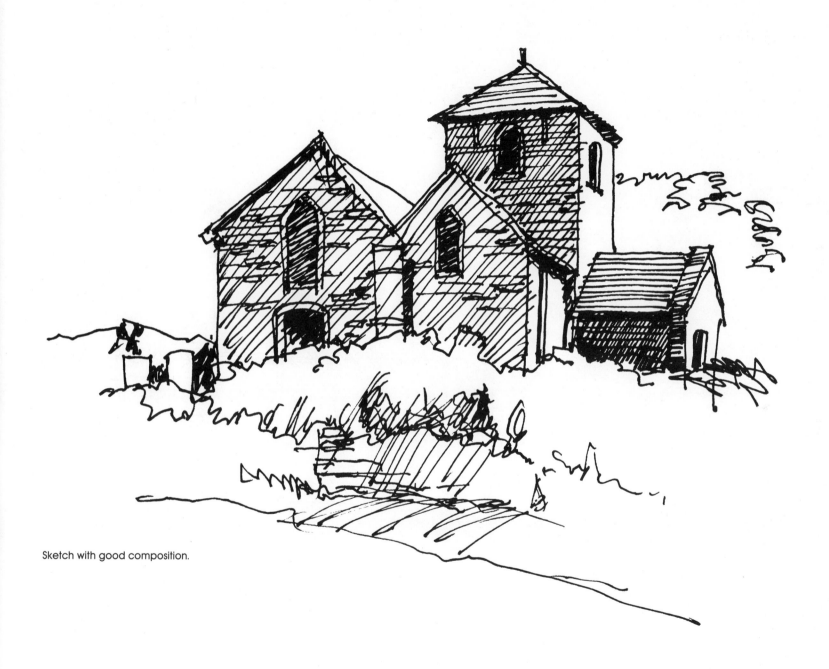

Sketch with good composition.

Frames

Composition of elements within a view is aided considerably by selecting a frame for the view you intend to sketch. Generally these would be rectangular frames, either horizontal or vertical. For a given view there are often several framing possibilities from which to make a selection. Once this is decided, the frame can be used as an orienting device for composing your sketch. In the café sketch, for example, the front of the standing man is at about the middle of the frame going from left to right, the top of his head is below three-quarters of the height of the frame. Other objects or people can be positioned in a similar way. This also helps one develop a two-dimensional perception of the view. In selecting the frame for the view, you will become aware of qualities of the subject and the view: balance, emphasis, contrasts, verticality, horizontality, tension. Awareness of these qualities will help not only in selecting the view but also in developing tone and detail.

Perception of views and the composition of elements within them takes practice. Here are some suggestions for getting started.

1. View a subject through a window or fixed sheet of transparent material. Closing one eye and keeping your head in one position, trace outlines of the subject on the transparent surface. Note the differences between the outline and your view with both eyes open.
2. Practice sketching basic compositions of scenes from slides. The two-dimensional reality of the projected slide and its built-in framing of the subject are quite helpful to perception of the composition.
3. Carry an empty photographic slide mount with you. When you have selected a direction from which to view your subject, use the slide mount to establish a frame for the view you wish to sketch.

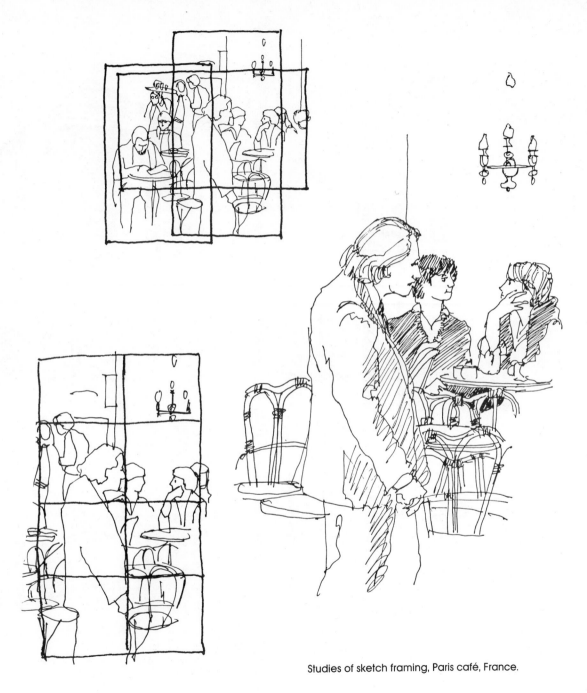

Studies of sketch framing, Paris café, France.

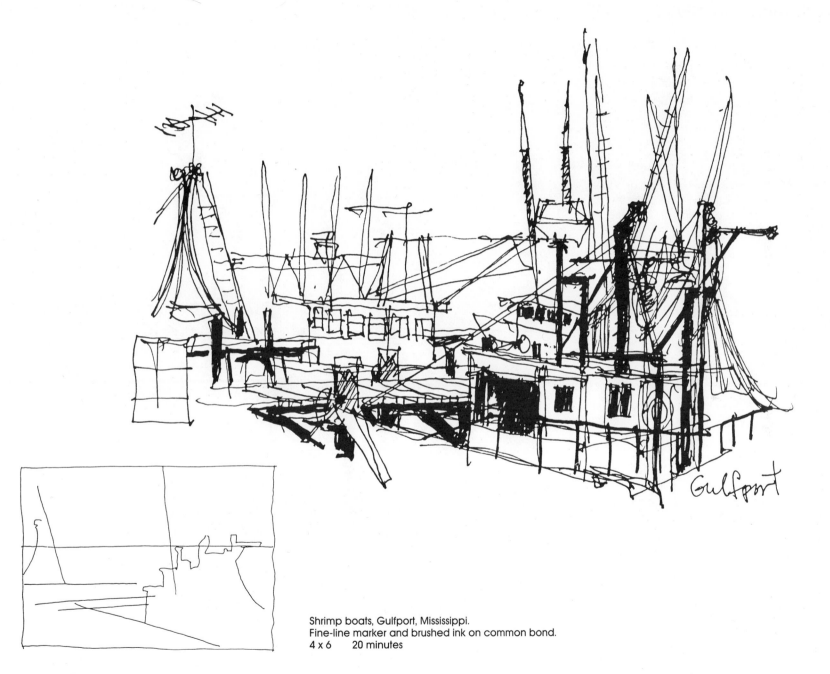

Shrimp boats, Gulfport, Mississippi.
Fine-line marker and brushed ink on common bond.
4 x 6 20 minutes

Frames within Frames

Composition can be further aided by setting additional frames within the sketch itself. They can be used to separate the foreground of a view from the middle ground and the middle ground from the background. The frames can also serve as a reminder to consider differences in tone or details that indicate different depths. For example, a window and a tree should be sketched with different degrees of detail, and the roof or wall of a building should have different intensities of tone, depending on their distance from you.

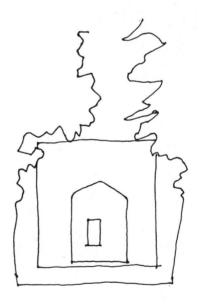

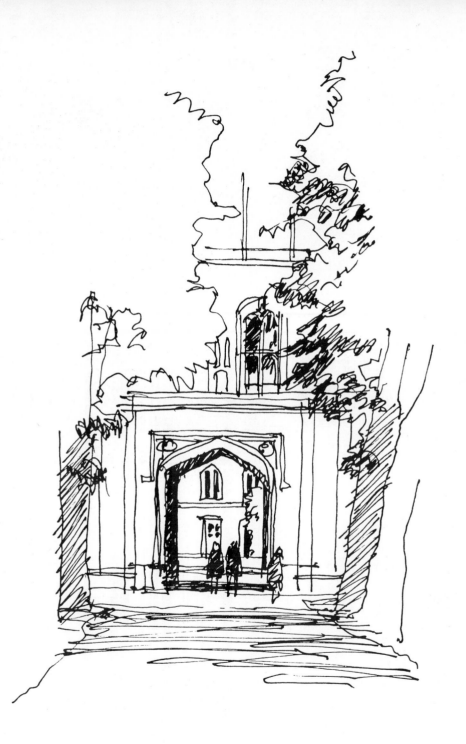

Frames within frames, Cambridge, England.

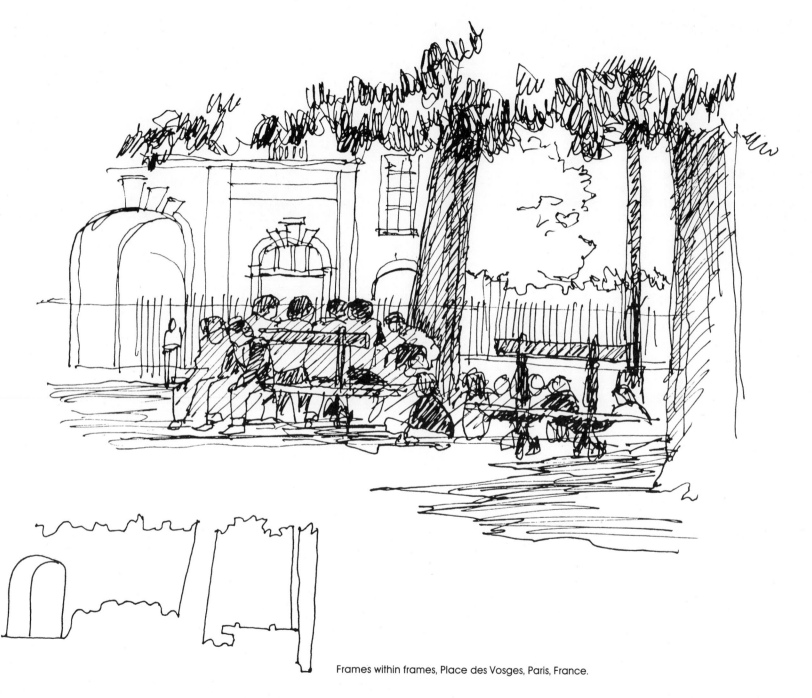

Frames within frames, Place des Vosges, Paris, France.

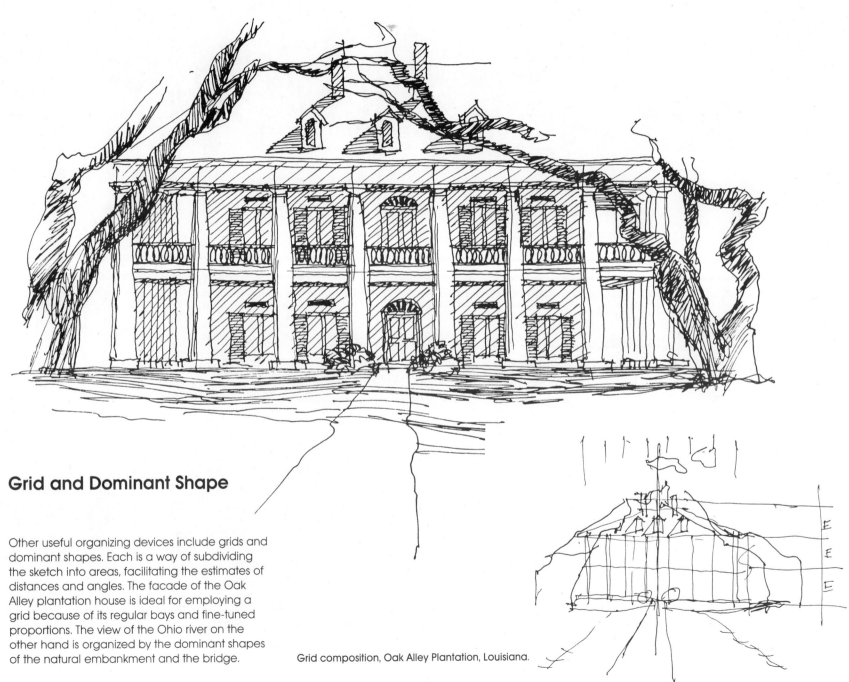

Grid and Dominant Shape

Other useful organizing devices include grids and dominant shapes. Each is a way of subdividing the sketch into areas, facilitating the estimates of distances and angles. The facade of the Oak Alley plantation house is ideal for employing a grid because of its regular bays and fine-tuned proportions. The view of the Ohio river on the other hand is organized by the dominant shapes of the natural embankment and the bridge.

Grid composition, Oak Alley Plantation, Louisiana.

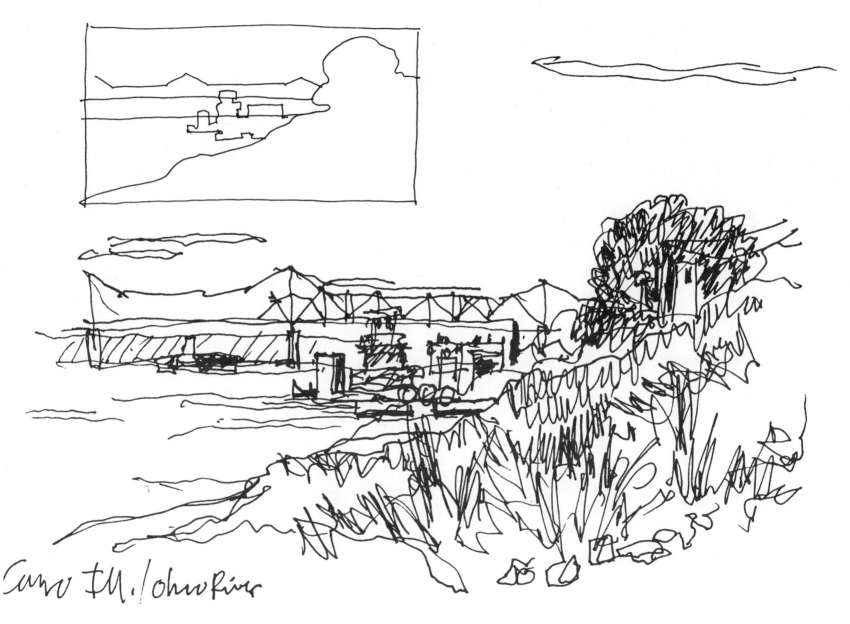

Cairo Ill. / Ohio River

Dominant shape composition, Cairo, Illinois.

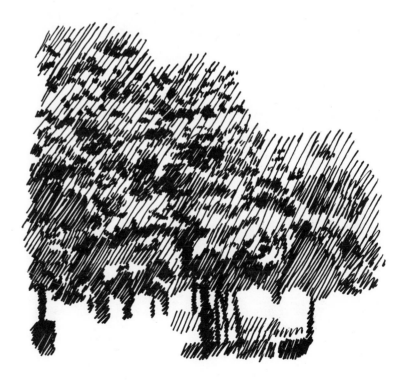

5. TONE

Space and form are revealed to us through the patterns of tone created by light. Tones are what give a sketch reality and a sense of space and form. Often sketching is our first opportunity to become fully aware of the values (lightness or darkness) of tones and their impact on our perception of the visual world. A striking facade of a building often depends for its effect upon the high contrast in tone between the windows and walls. The wide range of subtle patterns in the leaves of a tree are almost entirely visible through variations in tone.

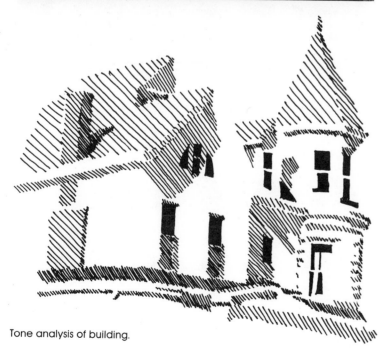

Tone analysis of building.

Tone analysis of trees.

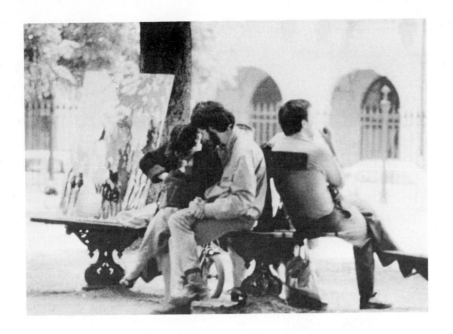

Before you apply tones to your sketch, you should make yourself aware of the variation and composition of tones within the view. A ready way to do this is to squint so that you can not see details, just the tones. When sketching from projected slides, simply turn the lens so that the picture is out of focus. Identify the lightest and darkest tones and then try to determine three or four gradations of intermediate values. This will prepare you for planning the application of tones to your sketch.

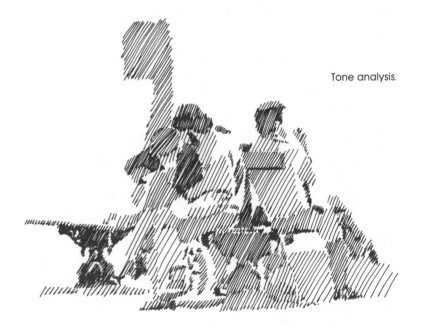

Tone analysis.

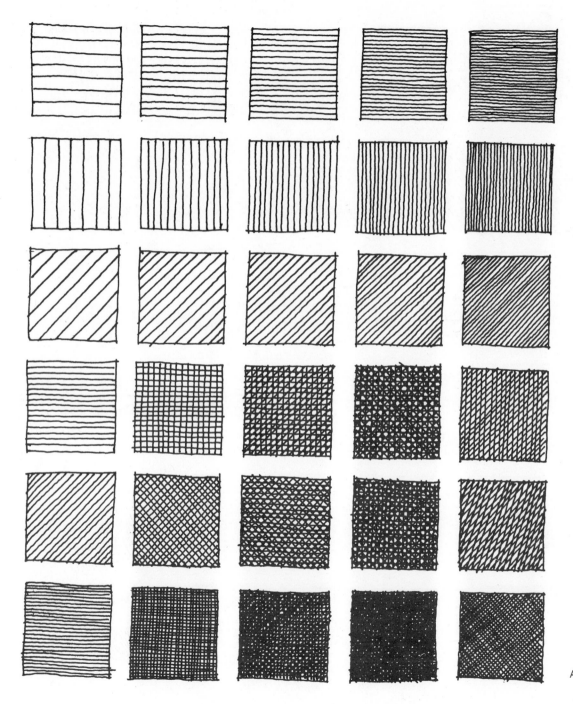

Applying Tones

A basic technique for applying tones in ink-line sketches uses hatching—equally spaced parallel lines. Variation of tone value is achieved by drawing the lines closer together or farther apart. Additional degrees of variation can be added through different types of crosshatching. Much of the character of individual styles of sketching is derived from different techniques for indicating tone. A variety of techniques is demonstrated in chapter 8.

In applying tones to specific sketches, it is important first to distinguish different sources of tone: the tones created by the density of a texture such as bark on a tree or siding on a house; the tones of the actual colors of forms; and the tones of shade and shadow created by the action of light upon forms. My approach to applying tones to a sketch is to apply them in the sequence of texture, color, and then light and shadow.

Array of tones.

Texture

The dividing line between texture and color can often be muddied when the sketcher is producing tone. Brick, for example, is often rendered as tightly packed horizontal lines. The lines may recall the horizontal rows of brick, but they also produce a gray tone, and this may cause the brick to appear too dark in color. When representing dense textures, such as brick, it is important to be aware of the values they create. If the resulting value is too dark for the color of the surface, you may have to eliminate or greatly reduce indications of texture; a slight variation in rendering texture may suffice. If the density of the texture indication produces a too-light tone, the area can be darkened with additional crosshatching.

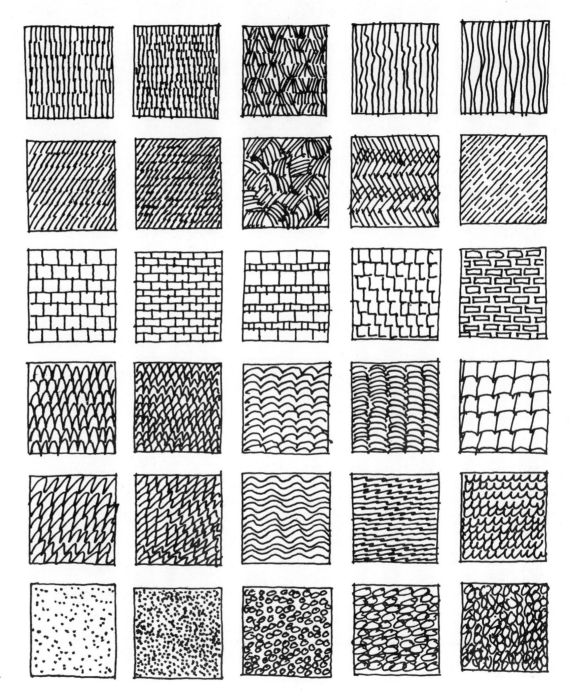

Array of textures and patterns.

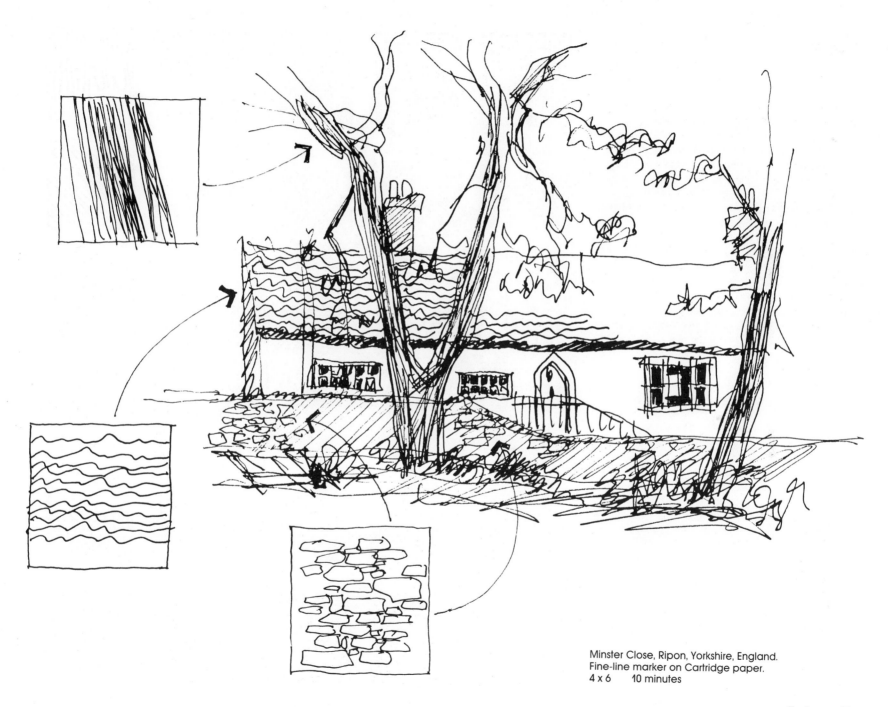

Minster Close, Ripon, Yorkshire, England.
Fine-line marker on Cartridge paper.
4 x 6 10 minutes

Color

Representing color in the normal black-and-white medium of a sketch may seem a contradiction in terms. However, theory about color generally recognizes its three attributes: hue, intensity, and value. *Hue* is the distinguishing attribute of color represented by the color wheel, namely red, blue, orange, and so on. *Intensity* is the amount of color present: pink is a red of low intensity; gray is a combination of colors of very low intensity. The third attribute of color, *value,* is the lightness or darkness of a color. While value is a very important attribute of color as it appears in objects or environments, it is the least understood. As the tavern sign illustrates, sharp contrasts in value are an important means by which color achieves emphasis and interest. On the other hand, a wide range of values like those in the sketch of barns in southeast Ohio can convey much of the subtleties of color found in landscapes.

When first sketching, it is often difficult to discern the relative values of color, because of all the other information and associations colors convey. Squinting is the quickest way to begin to sort out values. In order to distinguish color from texture, color should usually be applied diagonally on surfaces or in such a way as not to be confused with the edges of the surfaces or indications of texture. Practice in producing ranges of values, such as those shown below, may improve your skill. As you gain experience in sketching, you will want to try different approaches to indicating color-generated tones.

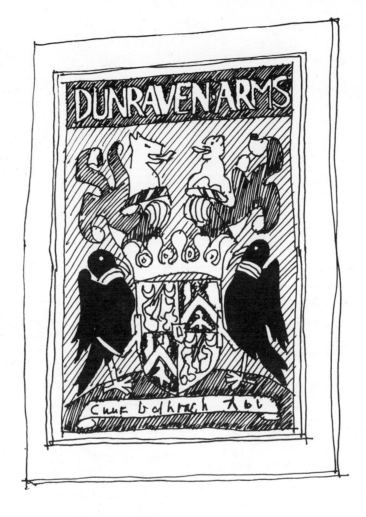

Dunraven Arms pub, Ireland.
Fine-line marker on Cartridge paper.
4 x 6 20 minutes

Variations in color value.

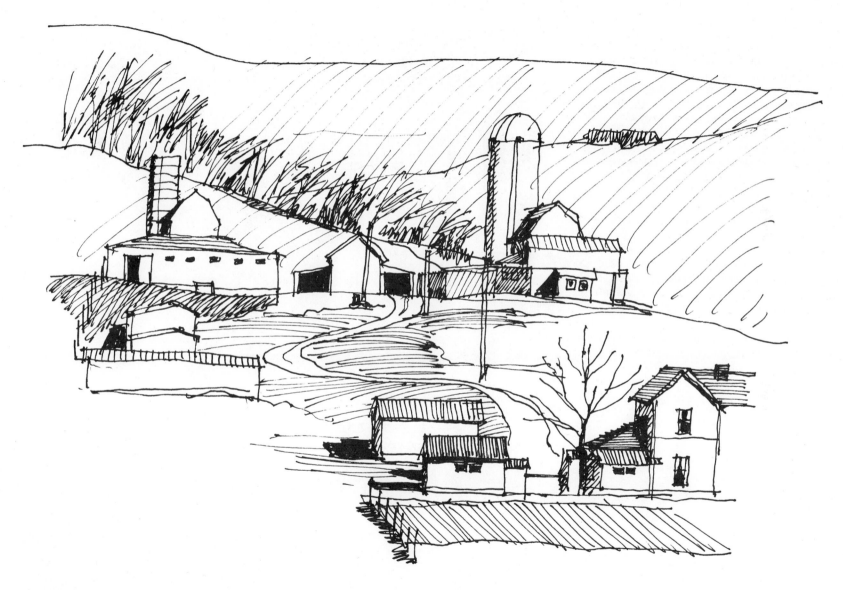

Barn group, Athens County, Ohio.
Fine-line marker on common bond.
9 x 12 20 minutes

Shade and Shadow

The last tones to be applied are those created by the action of light upon forms or spaces. Shade is generally a relatively dark area to be found on the surfaces of objects that do not receive direct light. Shadow is a dark area cast onto other surfaces by objects that block light. Except in cases of extreme contrast, both shade and shadow are transparent; that is, we can usually see details and textures within the areas of darkness with varying degrees of clarity. In order to convey this transparency, you should draw shade and shadow tones at an angle to both texture and color, hatching wherever possible.

Often shade or shadow is not uniform in tone or density. One way to render subtle shifts in tone is to add layers of hatching at different angles. Another approach uses shorter strokes of varying density over the more uniform hatching of color or texture.

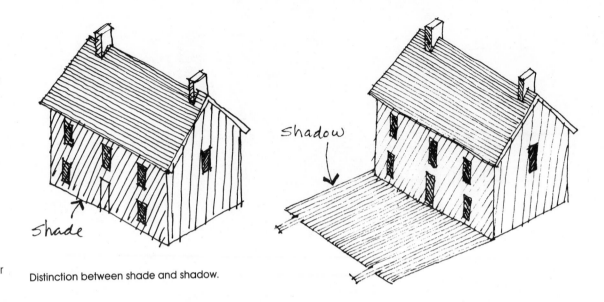

Distinction between shade and shadow.

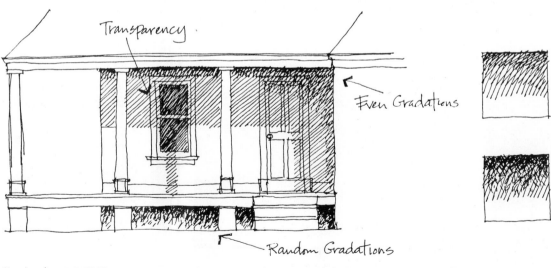

Shadow transparency.

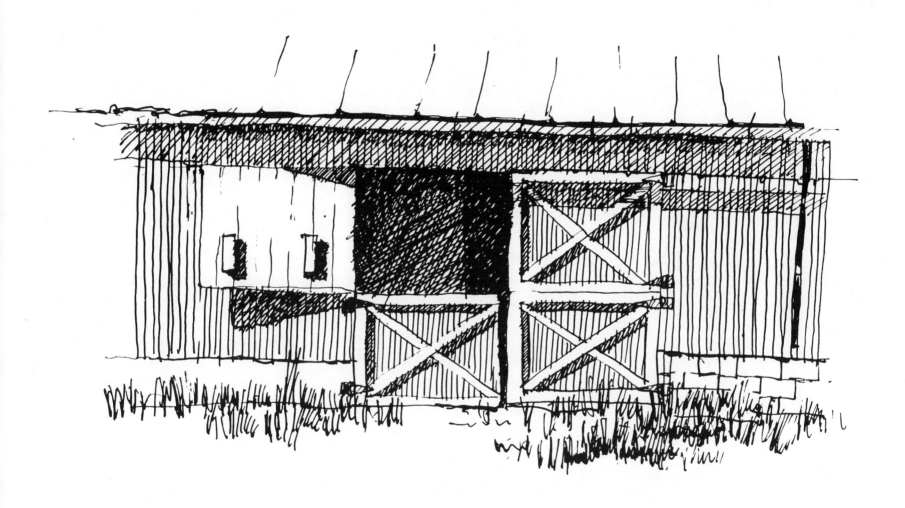

Flourny's / Athens Ohio / 1974

P. Larean

Flournoy barn, Athens County, Ohio.
India ink on Strathmore 400 series drawing paper.
9 x 12 15 minutes

A typical sketch, such as that of Richard Meier's
Atheneum in New Harmony, Indiana, will include
several types of tone indication: texture, pattern,
color, shade, shadow, transparency, and
gradation.

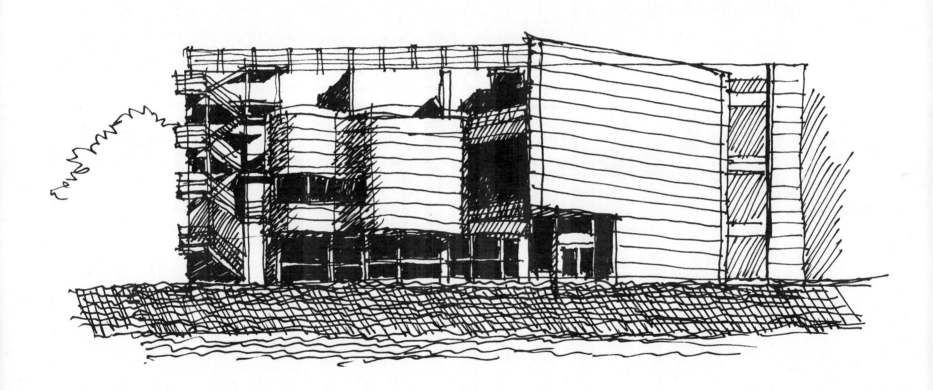

Atheneum, New Harmony, Indiana.
Fine-line marker on common bond.
8 x 10 20 minutes

Shape and Volume

Because of the ways in which objects of different shapes and materials intercept, reflect, or distort light, tone is effective in depicting shape and volume. Variations in tones can be subtle and often defy analysis. It is important to render them just as they are seen, paying particular attention to detail configurations of tones. Although longer parallel-line tones may be used, short stroke techniques are often more effective.

Rendering shape and volume.

Oak Alley

Oak Alley Plantation, Louisiana.
Fine-line marker on common bond.
5 x 7 20 minutes

Modeling strokes.

6. DETAIL, TEXTURE, PATTERN

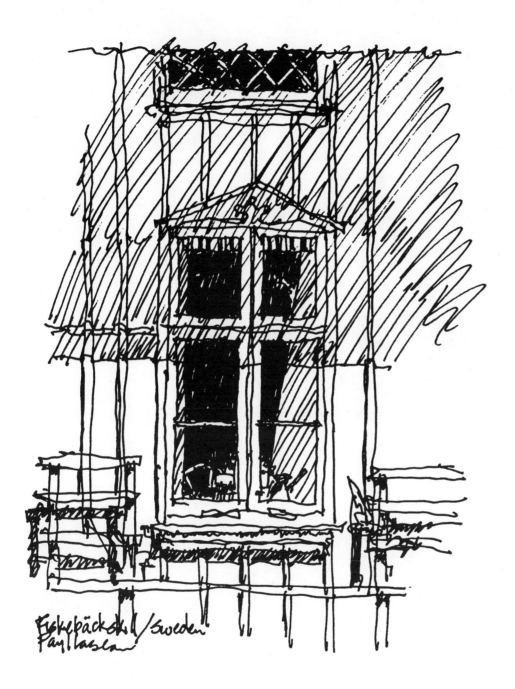

Fiskebäckskil / Sweden
Paul Laseau

Much of the quality or character of a subject can be conveyed through carefully sketched details. It is in sketching the details that your powers of observation are most severely taxed. To promote success and enjoyment in sketching, I approach each drawing as if it were a mystery and I a detective looking for clues. When I first pick out a subject for sketching, I intuitively know that it has intriguing or stimulating qualities. Sketching is my investigation of the source of those qualities. If I succeed, it will be reflected in the sketch, and I will become a better detective.

Details tell us much about a subject: the inherent qualities of the materials—soft, brittle, slippery, coarse, smooth, heavy, light; the way in which the subject was constructed, joined, or fashioned; the effects of climate and nature over time; and the ways in which the subject is or has been used. Sketching details focuses our attention on the many dimensions of our subject and greatly expands our awareness of the physical world around us.

Traditional house window, Fiskebackskil, Sweden. Fountain pen on Cartridge paper.
4 x 6 15 minutes

Approach to Detail

Often you can be overwhelmed by the amount of detail in the view you are sketching. If you dwell on the apparent vastness of your task, you can become worn out before you start. To avoid this problem, remember your role as a detective; seek out the specific details that are the basis for a texture or pattern. These details might be the typical method of laying brick or stone, the arrangement of leaves in a tree or plant, overlapping of straw in a basket, divisions in a window or wrinkles in a face. Carefully record the typical detail, including written notes where helpful; then leave the rest of the detail indication to a time when you feel less pressed. I usually find that, when I come back to a sketch to insert textures and patterns, my enthusiasm is renewed and my perceptions enriched. Although much of the charm of a sketch may be found in the spontaneity of immediate reactions to a subject, sometimes postponing completion brings a detachment that can introduce important refinements.

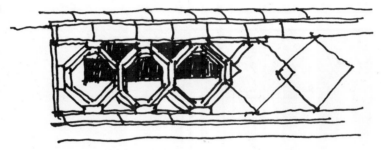

Details from Lincoln Market.
Fine-line marker on Cartridge paper.
6 x 6 10 minutes

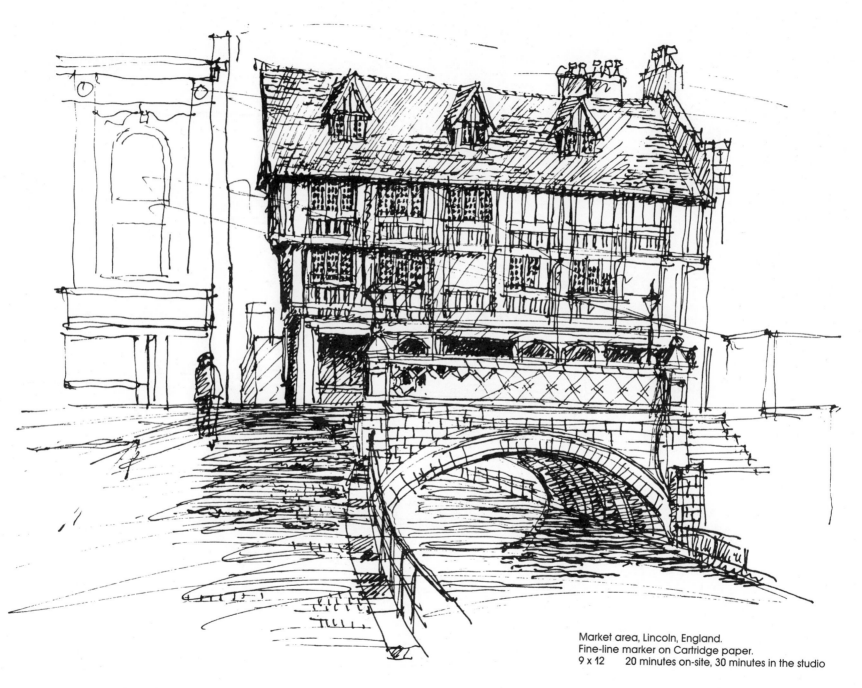

Market area, Lincoln, England.
Fine-line marker on Cartridge paper.
9 x 12 20 minutes on-site, 30 minutes in the studio

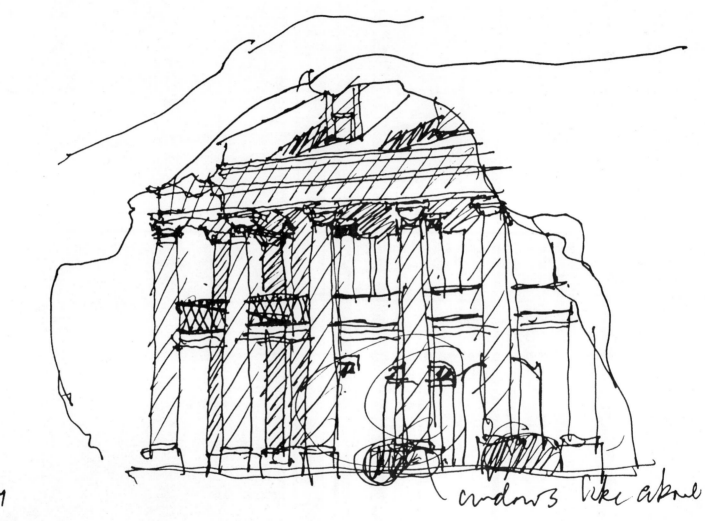

Oak Alley

windows like above

Louisiana plantation, on-site sketch.

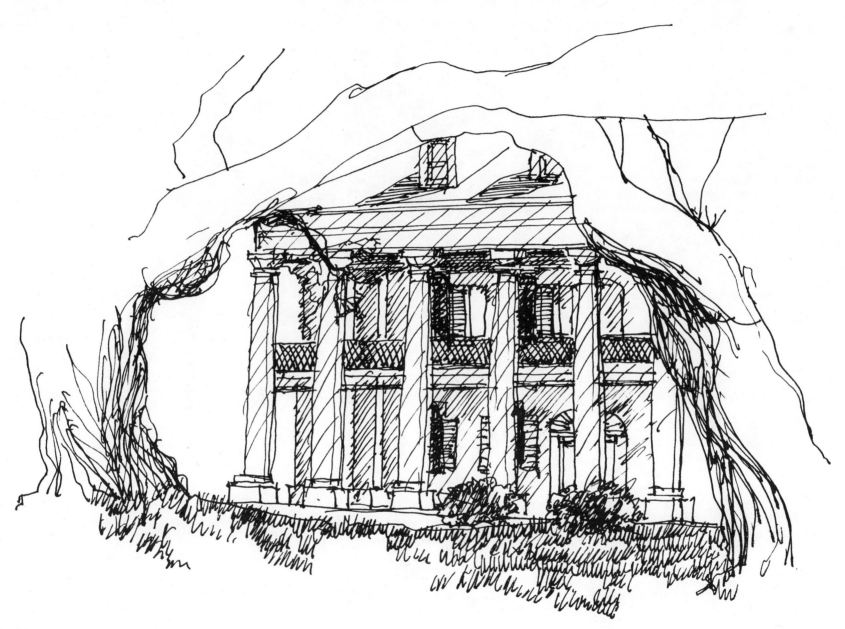

Louisiana plantation, finished sketch.
Fine-line marker on Cartridge paper.
9 x 12 20 minutes

Selectivity

While it is important to *see* the details of a subject, it is not necessary to *render* all of them. A sketch never can and never should be identical to a subject. As a two-dimensional object intended to be viewed at close range, a sketch has an existence apart from its subject. A sketch has its own requirements as a communicating artifact. Although the subject is the basis of the message conveyed by a sketch, the effectiveness of the communication depends to an extent on the use of the media of the sketch. If, for example, all the pattern is fully rendered, the result may be a boring, monotonous, or lifeless sketch. If the process of sketching the pattern were equally boring, it could affect your attitude and thereby other parts of the sketch. In communication terms, too much noise has entered the system; the dominance of the pattern has obscured other messages in the sketch. But if you apply pattern or detail so as to support your interest and insight about the subject, the result is often more interesting to the viewer.

At times you may even leave areas of a sketch blank. These open areas can be useful to the composition of a sketch, leading the viewer's eye around the sketch or creating a stimulating tension. Omission of information can also be a means of involving the viewer, stimulating his or her imagination to consider the possibilities or supply the missing information.

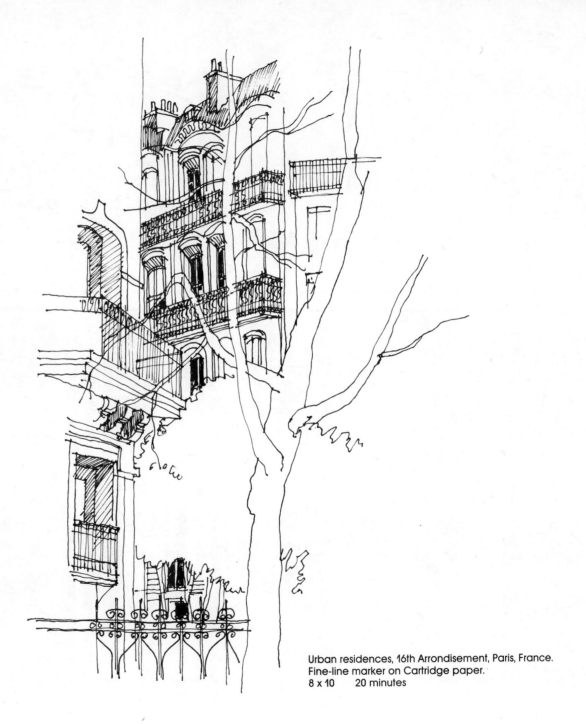

Urban residences, 16th Arrondisement, Paris, France.
Fine-line marker on Cartridge paper.
8 x 10 20 minutes

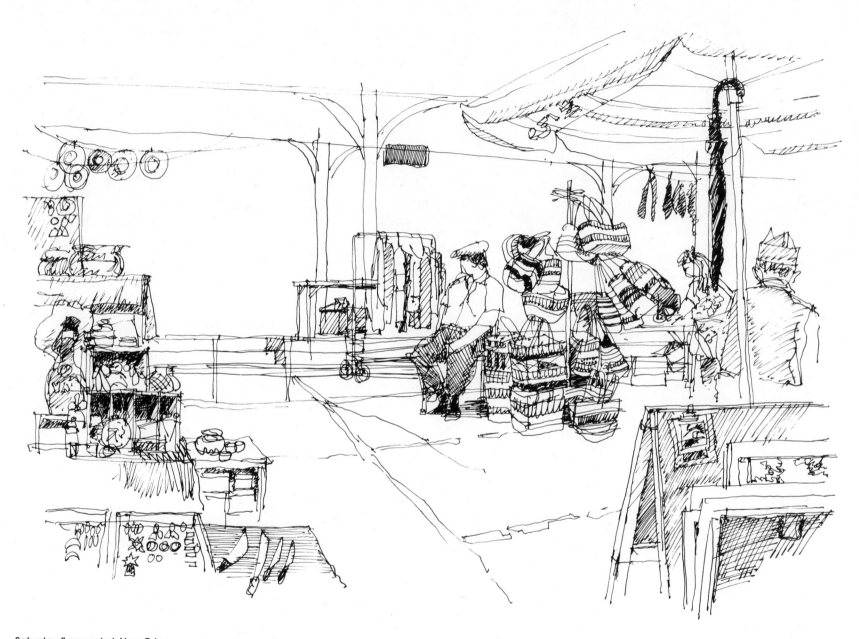

Saturday flea market, New Orleans.
Osmiroid Rolatip Extra Fine nib on 1-ply bristol board.
11 x 14 30 minutes

street scene from B/I/T was done (upon or

7. SKETCH-BUILDING EXAMPLES

Composition, tone, and detail are ways of seeing as well as steps in building sketches. In practice I apply these ways of seeing and representing in several different approaches. The way in which a sketch is realized is influenced partly by circumstances and partly by my interests. When I first saw the Hovercrafts at Dover, England, I knew immediately that they would make a fantastic subject for a sketch, but I also felt that I could not do justice to the subject in the limited time I had before leaving for France, so I took a few pictures with a small, pocket-sized camera for future reference. Normally, after studying the pictures, I would complete this sketch quickly, in one shot. In this case, I took a short break to photograph the drawing as it was evolving. The first sketch of the street scene from Bath was done rapidly on-site. The second illustration shows the same sketch after tones and details were completed. The first rough sketch of the barn was a quick attempt to capture the unique qualities of the setting. Using this sketch as reference, I produced a second sketch in a specific style I was using for a series of sketches of Ohio Valley barns. The fourth subject, the village of West Looe, was the basis for a fairly complete sketch. Although this sketch showed some interesting qualities, I did not feel it conveyed the rich variety of textures and patterns of the scene itself. To achieve this, a second drawing was done at more than twice the size of the original sketch. The second drawing was composed by laying a piece of tracing paper over the sketch and doing an analysis with respect to a grid. The grid was then reproduced in light pencil at the larger scale to guide work on the final drawing.

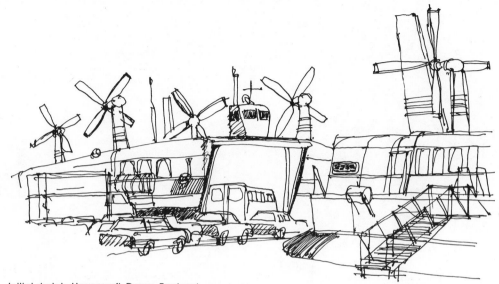

Initial sketch, Hovercraft, Dover, England.
Osmiroid Rolatip Extra Fine nib on 1-ply bristol board.
10 x 8 10 minutes

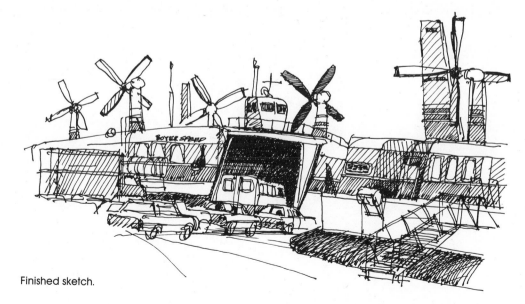

Finished sketch.

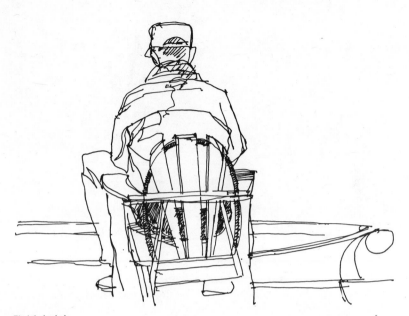

Field sketch.

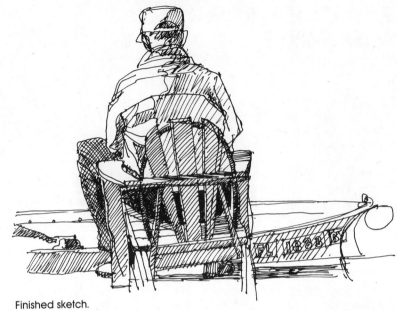

Finished sketch.

Field sketch.

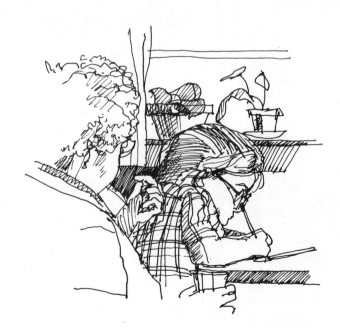

Finished sketch.

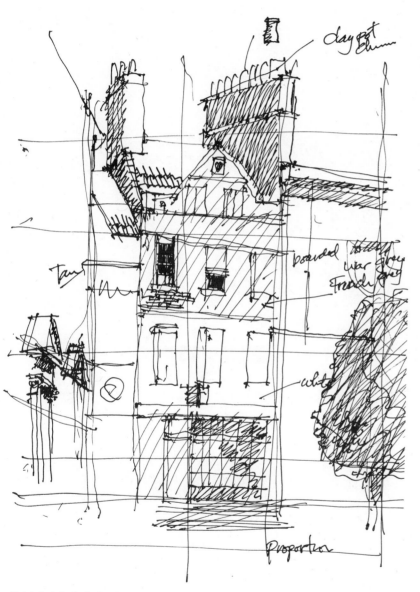

Field sketch, Bath, England.
Fine-line marker on common bond.
8 x 11 10 minutes

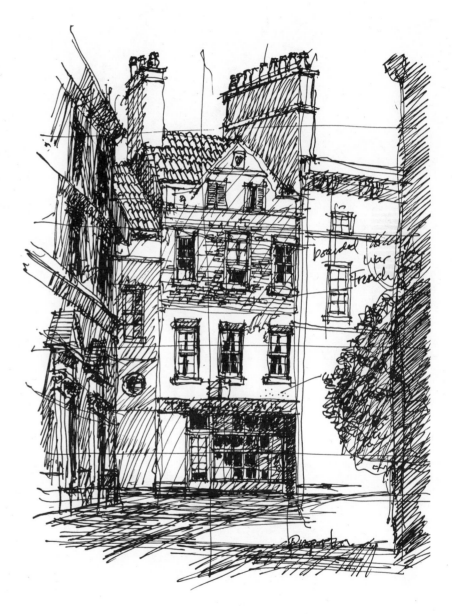

Finished sketch.

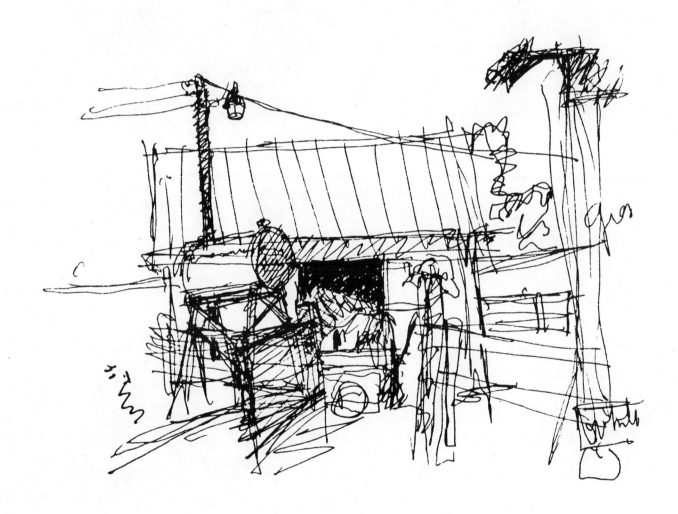

Field sketch, Barn in Athens County, Ohio.
Fine-line marker on onionskin paper.
4 x 6 10 minutes

64 Sketch-Building Examples

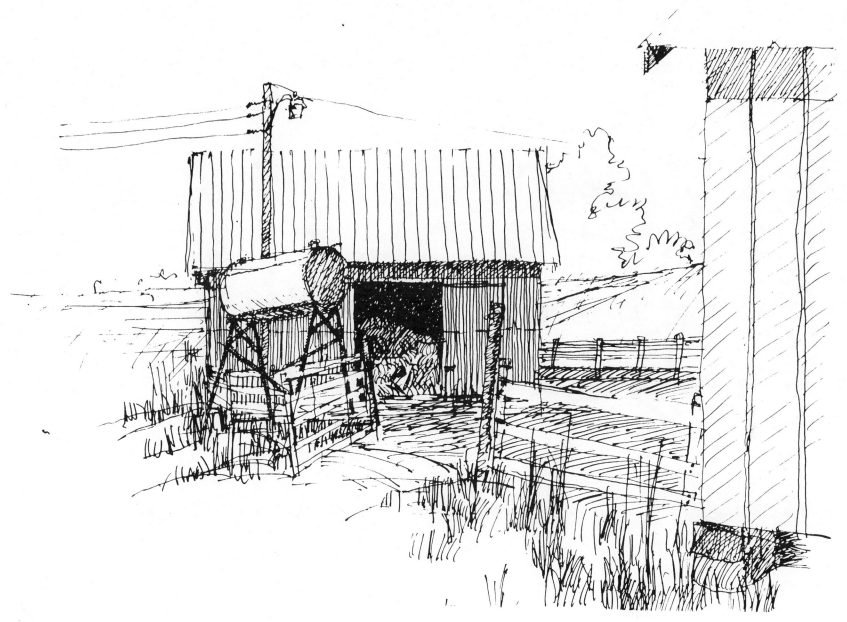

Finished sketch.
Fine-line marker on Strathmore 400 drawing paper.
9 x 12 25 minutes

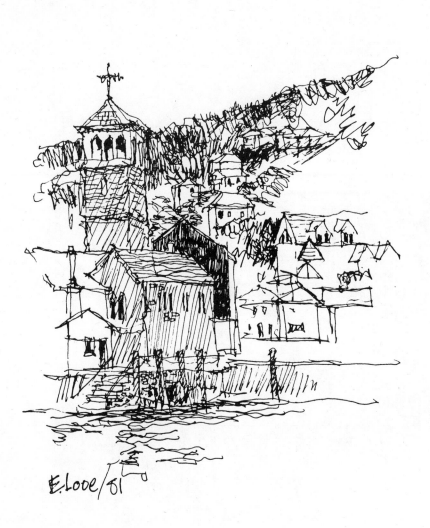

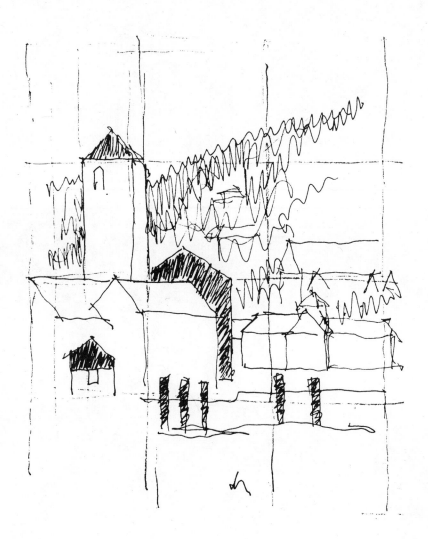

Field sketch, West Looe, Cornwall, England.
Fine-line marker on bond paper.
4 x 6 15 minutes

Analysis of composition.

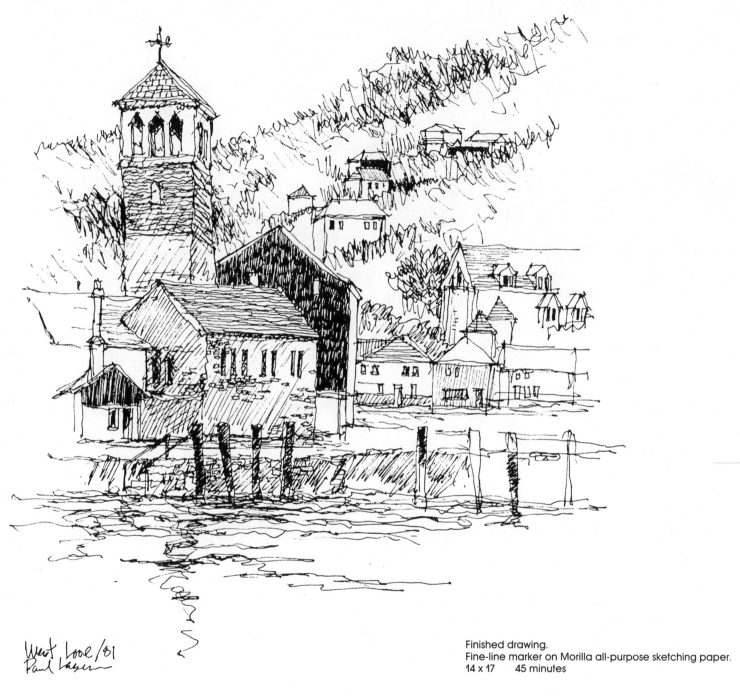

West Looe/81
Paul Laseau

Finished drawing.
Fine-line marker on Morilla all-purpose sketching paper.
14 x 17 45 minutes

Fast Sketches

In practice careful sketches should be balanced with regular attempts at rapidly capturing subjects in one- to five-minute sketches. Otherwise your sketching and seeing experience will tend to be limited to accessible, immobile subjects. This usually excludes an important class of subjects, people. People are often the source of animation, vitality, or interest in environments. As subjects they present challenges that will help you develop skill. As in all drawing, the key is fresh, clear observation. Fast sketches of stable subjects such as the harbor at Lyme Regis are also good exercises, both in hand-control skills and in attempting to capture the essence of an experience.

Street people, New Orleans
Fine-line marker on common bond
7 x 9 1–4 minutes each

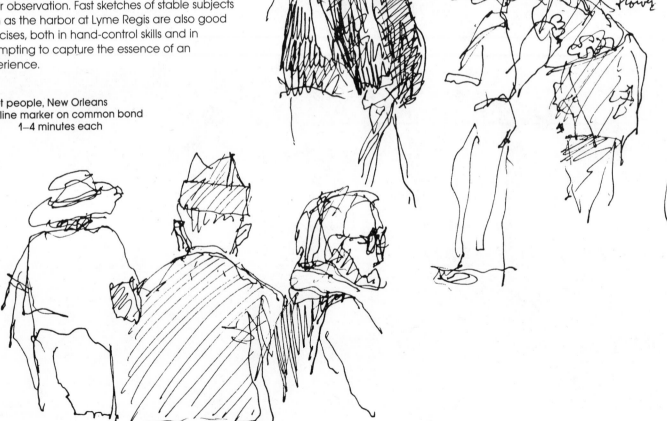
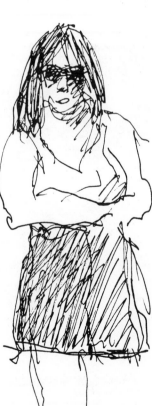

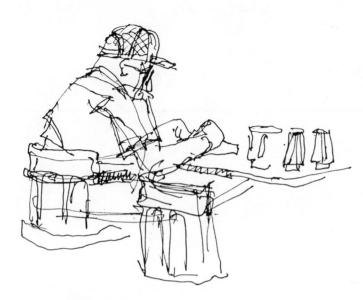

Fast-food restaurant, Tell City, Indiana.
Fine-line marker on common bond.
6 x 4 5 minutes

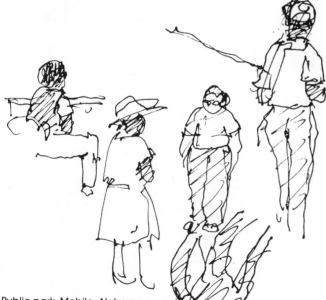

Public park, Mobile, Alabama.
Fine-line marker on common bond.
4 x 6 10 minutes

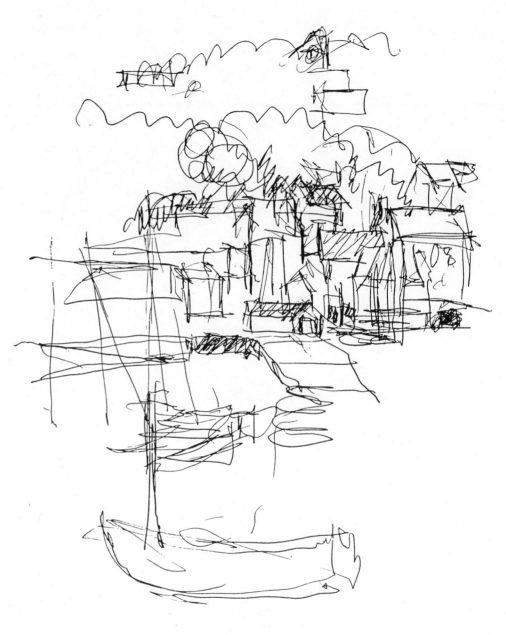

Harbor, Lyme Regis, England.
Fine-line marker on common bond.
8 x 10 5 minutes

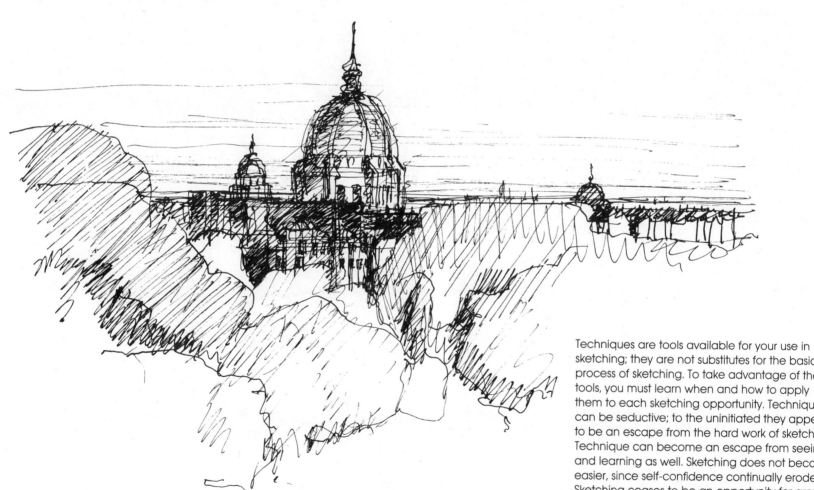

Paris skyline.
Fine-line marker on common bond.
8 x 10 20 minutes

Techniques are tools available for your use in sketching; they are not substitutes for the basic process of sketching. To take advantage of these tools, you must learn when and how to apply them to each sketching opportunity. Techniques can be seductive; to the uninitiated they appear to be an escape from the hard work of sketching. Technique can become an escape from seeing and learning as well. Sketching does not become easier, since self-confidence continually erodes. Sketching ceases to be an opportunity for growth and becomes an uninteresting regurgitation of clichés. If, however, you remain dedicated to sketching as a means of seeing and understanding, techniques can be a source of enrichment for your drawings.

Style vs. Cliché

Some people adopt clichés in sketching because they mistake them for style. Although there are some superficial similarities between cliché and style, the distinctions between them are far more significant. Clichés in sketching are methods of indication so commonly used that they have become symbols rather than representations. At their worst they are completely divorced from any attempt to show the reality of the subject (for example, three diagonal lines to indicate glass).

Sketch style, on the other hand, is distinctive, emerging from the unique perceptions and personality of the individual. Style develops over a long period of sketching experiences; it can not be forced into existence simply through logic or determination. Style is the expression of how we as individuals interpret the world. Style is active, not passive. Style should be flexible enough to respond to any situation rather than to impose preconceptions upon our understanding of the subject.

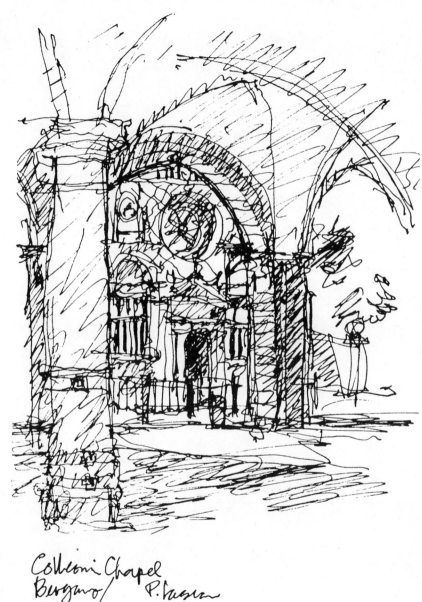

Colleoni Chapel, Bergamo, Italy.
Fountain pen on Cartridge paper.
5 x 7 15 minutes

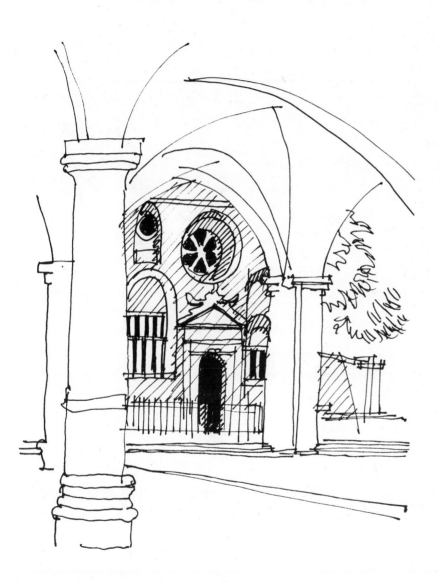

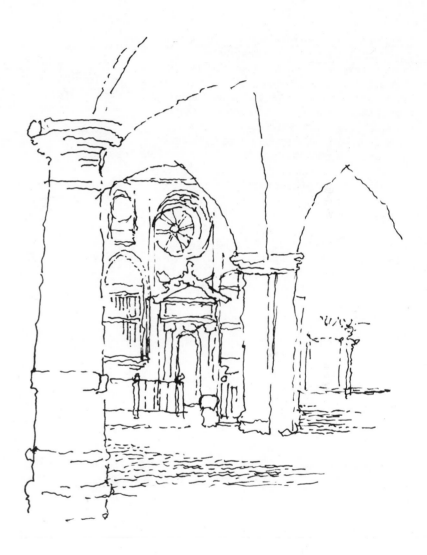

Colleoni Chapel.
Fine-line marker on common bond.
5 x 7 10 minutes

Colleoni Chapel.
Fine-line marker on common bond.
5 x 7 10 minutes

Line Types

Once you have developed basic sketching skills using simple straight lines, you will want to experiment with a wide range of line types. Variations in lines are created by one or a combination of three moves—lateral, back up, or skip. Change in line type can radically alter the appearance of a sketch and convey special feelings toward a subject. Line type can also convey secondary messages such as confidence, tentativeness, delicacy, informality, consistency, humor, exuberance, or restraint.

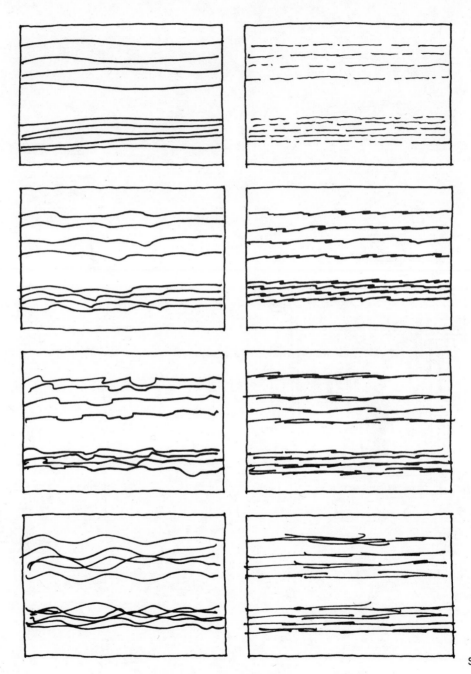

Samples of line types.

Line Tones

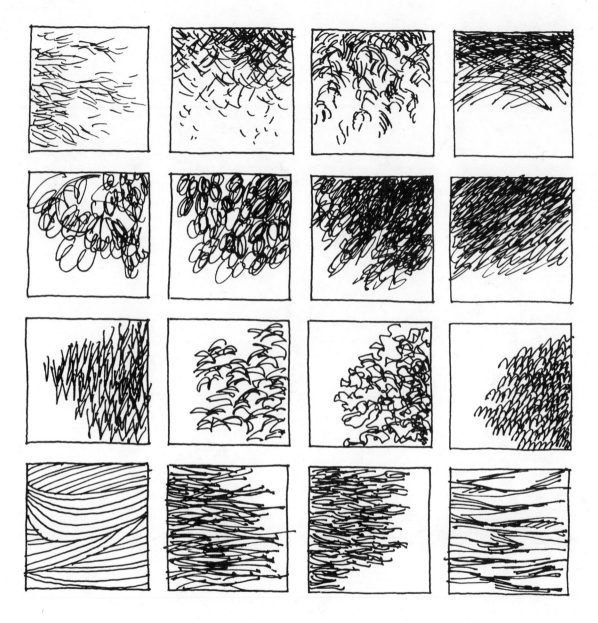

A large number of different tones can be created through varying the density of lines or combining line types. Generally I try to use techniques with which a full range of tones from light to dark can be made. In order to be comfortable with these different techniques, you should practice them as part of daily graphic exercise. Equally important is experimentation with techniques in response to each new sketching subject.

Samples of tone types.

Paper

The character or style of lines can also be altered by the use of different combinations of pen and paper. A fine-line marker can produce a light, delicate effect on watercolor paper. Sketching with a fountain pen on cartridge paper or bristol board can capture the liquid process of applying the ink, while fountain pen on a sheet of ink blotter can result in a softer, less controlled sketch. I am constantly experimenting with different pens on new types of paper in order to broaden the range of techniques available for sketching.

Rousham House, the Cotswolds, England.
Fine-line marker on Whatman 140# watercolor paper.
7 x 10 20 minutes

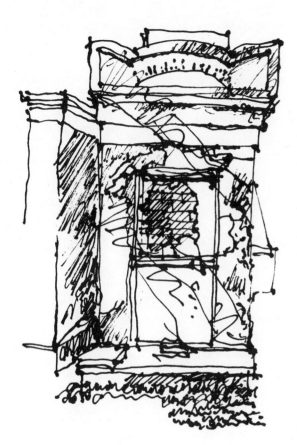

Graveyard, New Orleans.
Fountain pen on ink blotter.
4 x 7 10 minutes

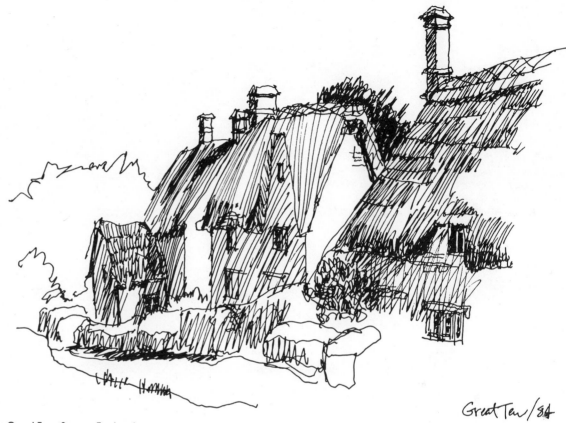

Great Tew /84

Great Tew, Sussex, England.
Fountain pen on Cartridge paper.
8 x 10 15 minutes

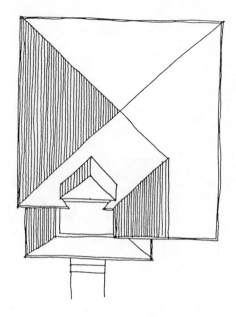

9. DRAWING CONVENTIONS

If lines and line tones are the vocabulary of ink-line sketching, then drawing conventions are an important part of the grammar. An understanding of drawing conventions does not guarantee good sketches, nor is it a substitute for seeing. Rather, these conventions are presented here as an extension or enrichment of evolving sketching skills.

Orthographic Projections

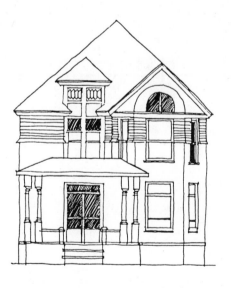

These are more commonly known as plans or elevations. They derive their technical name from one meaning of *ortho*, namely "straight" or "upright." While perspectives show the apparent relative size of objects, and some horizontal lines seem to slant toward the horizon, in orthographic projections, objects appear in their actual relative sizes, and all horizontal lines are straight, parallel with the horizon. For sketching, elevations are the most useful of these projections. They are relatively easy to construct and approximate some views one might experience. They can also be used to lend an air of stability or order to a drawing.

Evansville, Indiana.
Fine-line marker on common bond.
8 x 10 30 minutes

Perspective

To the extent that a sketch accurately represents what can be seen from a fixed position, a close correlation exists between the composition of a typical sketch and the convention of perspective. You can test this assumption by laying a piece of tracing paper over a sketch and tracing edges of objects. The extensions of edges that, in three dimensions, are actually parallel to the ground should meet on a line called the horizon. Horizontal lines that are parallel with each other should meet at a point on the horizon.

For me the basic reasons for understanding perspective are to be able to draw parts of a subject that can not be seen or to distort the proportions within the sketch on purpose. Knowing the rules provides me with the flexibility of violating them for a specific purpose, such as creating tension, emphasis, or a mood. Although my first sketch of the Lincoln Cathedral is more accurate, the second, distorted sketch conveys more of the drama one feels in the presence of the cathedral.

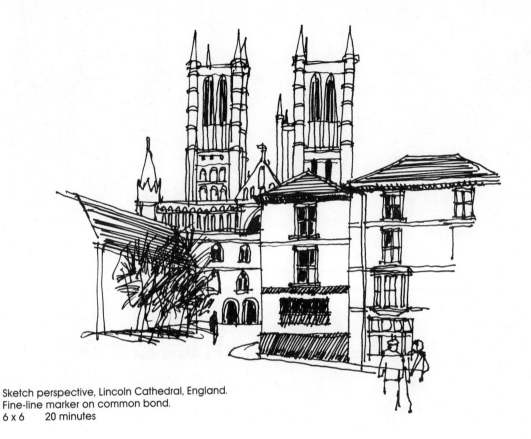

Sketch perspective, Lincoln Cathedral, England.
Fine-line marker on common bond.
6 x 6 20 minutes

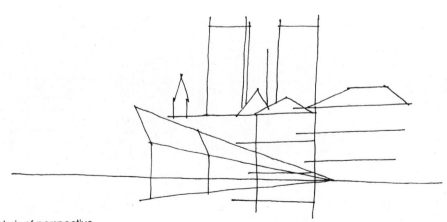

Analysis of perspective.

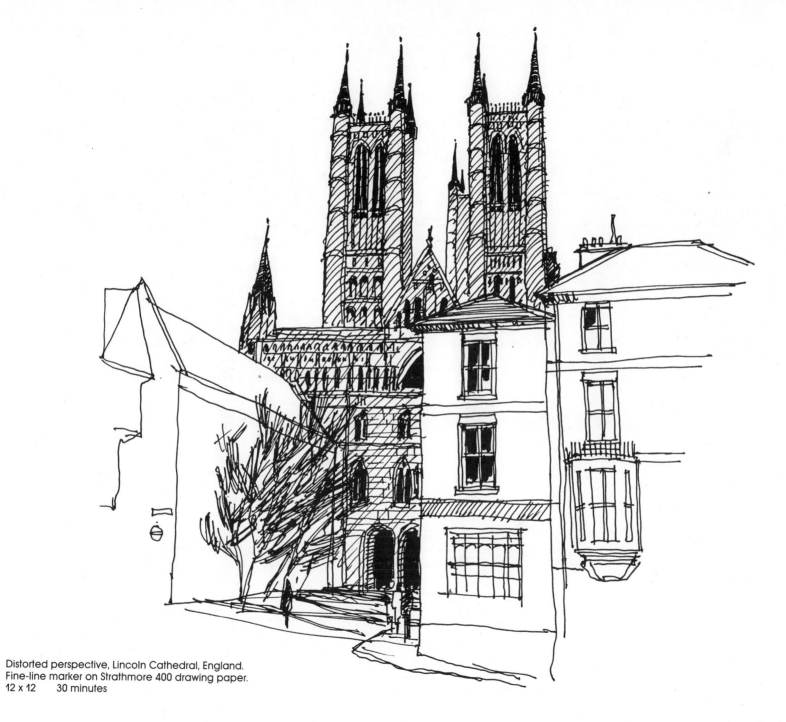

Distorted perspective, Lincoln Cathedral, England.
Fine-line marker on Strathmore 400 drawing paper.
12 x 12 30 minutes

Paraline Projections

Drawings within this convention convey three-dimensional objects or spaces by extending parallel lines from a vertical or horizontal plane. Unlike perspectives, paraline projections are not used to represent subjects as we see them. Instead they are often used to represent subjects in ways that we can only imagine. Tell City, Indiana, is packed into a narrow plateau between a set of hills and a levee wall overlooking the Ohio River. I could sense the impact of this unusual setting, but there was no position on the hills from which I could get a good view. In an attempt to capture the scene, I made several sketches such as those on this page and then used the convention of paraline projection to assemble an overall view of the industrial part of the town.

Field sketches, Tell City, Indiana.
Fine-line marker on Cartridge paper.

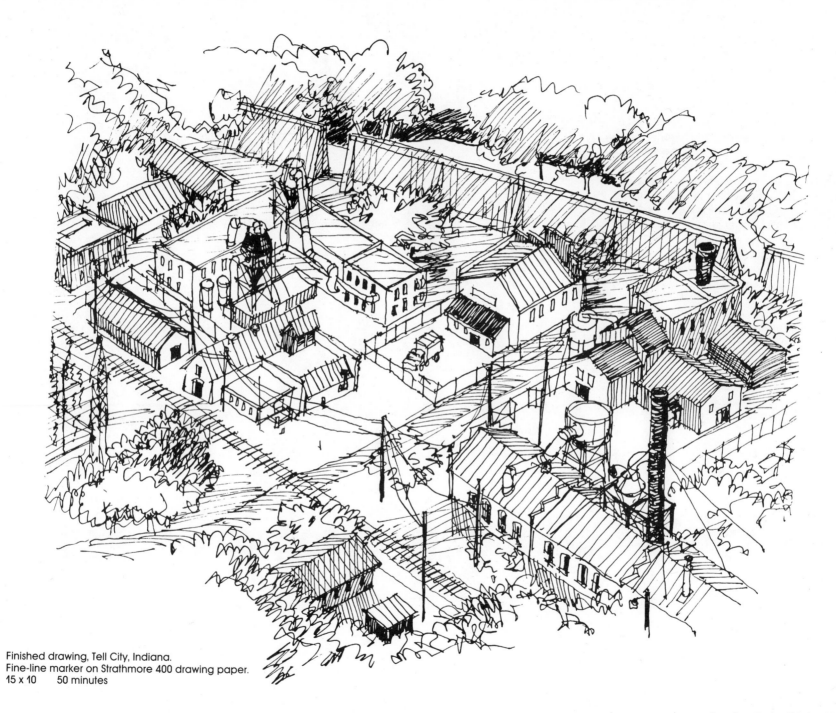

Finished drawing, Tell City, Indiana.
Fine-line marker on Strathmore 400 drawing paper.
15 x 10 50 minutes

Montage

An approach that has been a focus of experimentation for several individuals, the montage is just beginning to reach the status of a drawing convention. Although the term *montage* has its origins in photography, it best describes this type of drawing: "... combining several distinct pictures so that they often blend with or into each other to produce a composite picture; an impressionistic sequence of images linked usually by dissolves or super impositions ... to develop a single theme, suggest a state of mind, or bridge a time lapse." In sketching, montages disregard normal rules of perspective in order to illustrate more completely details of an experience. Montages act more as inventories than as realistic views. In the tradition of Cubist painting, these montages defy the constraints of time in order to provide a more comprehensive experience of a subject. This convention allows you to move more freely between realistic and abstract depictions of a subject, simultaneously using skills of observation and interpretation.

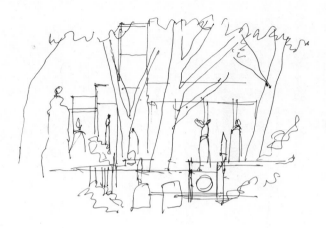

Montage composition, Church in St. Francisville, Louisiana.
Fine-line marker on common bond.
5 x 3 5 minutes

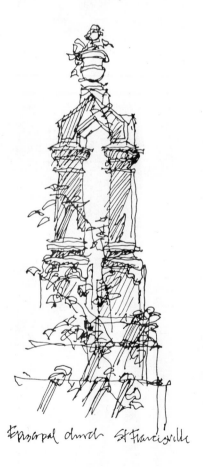

Field sketches.

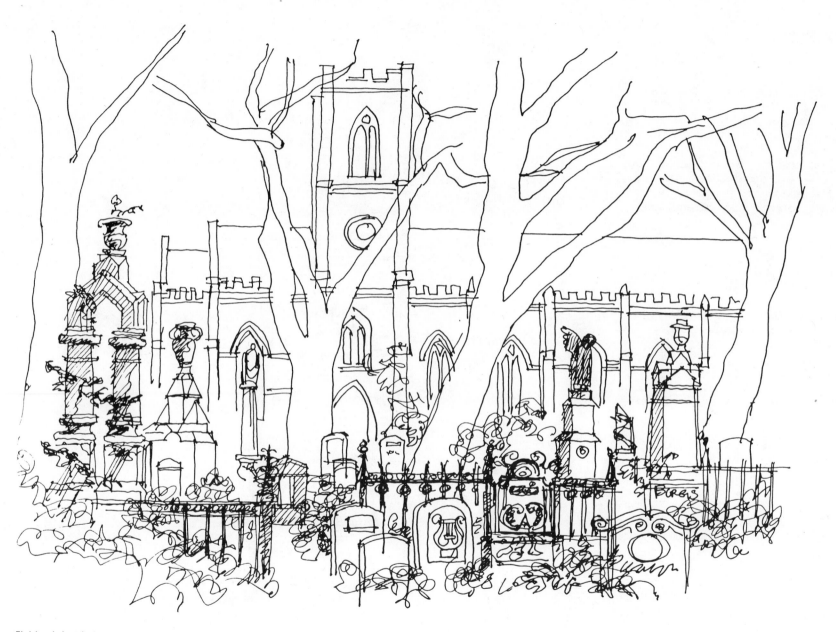

Finished drawing.
Osmiroid Rolatip Extra Fine nib on 1-ply bristol board.
15 x 10 45 minutes

Vignette

This type of drawing concentrates the rendering of tones and detail around the center of the drawing or focal points within the view; degree of rendering diminishes with proximity to the edge of the drawing. This convention imitates our visual ability to focus on one object in a cluttered scene, while disregarding the surrounding context. It is a form of selection with which we can direct attention or create emphasis.

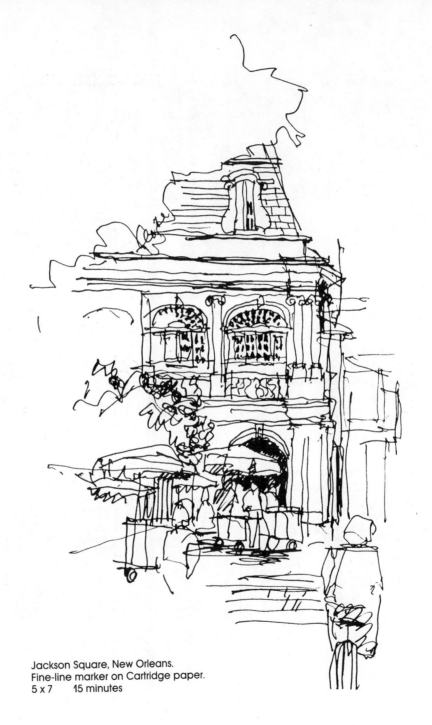

Jackson Square, New Orleans.
Fine-line marker on Cartridge paper.
5 x 7 15 minutes

Clams, Greenwich Village, New York City.
Fine-line marker on common bond.
8 x 3 15 minutes

Green beans, Paris market, France.
Fine-line marker on common bond.
4 x 4 10 minutes

Combined Techniques

Accomplished sketchers often make creative use
of drawing techniques by combining them in
ways that support their special view or
interpretation of a subject. When they are
confronted with subjects that they feel are
impossible to capture through normal means,
they invent devices that circumvent the limitations
of standard drawing conventions.

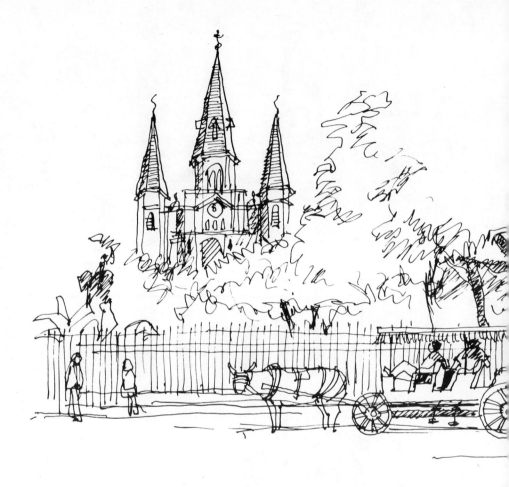

Jackson Square, Coffee House, New Orleans.
Osmiroid Extra Fine nib on 1-ply bristol board.
17 x 10 50 minutes

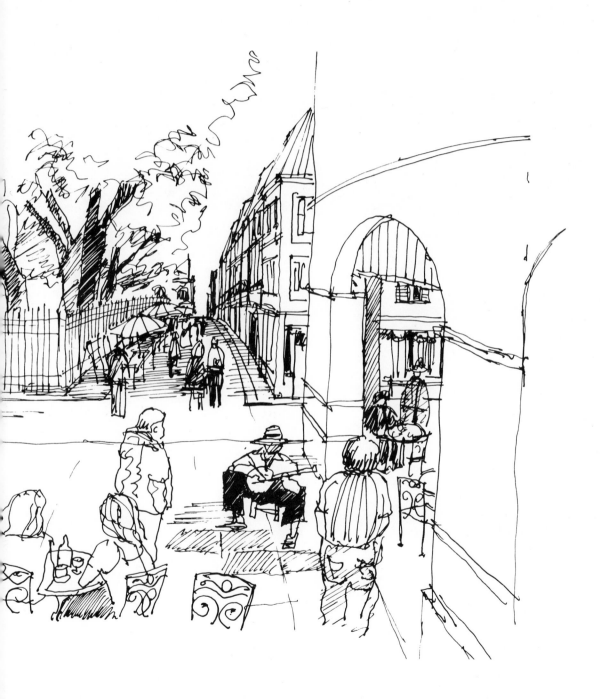

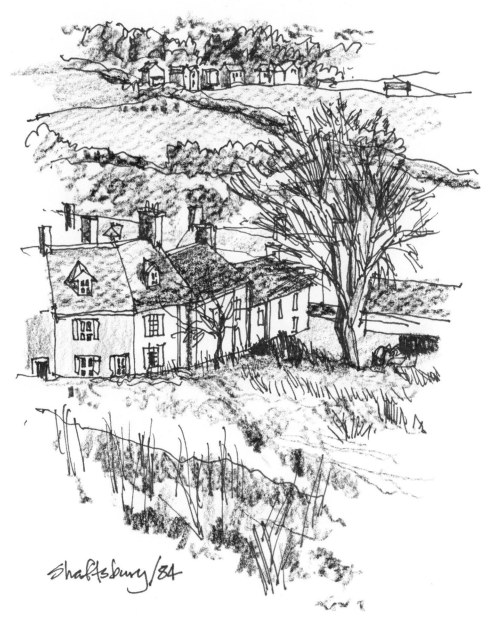

Shaftsbury, England.
Grease pencil on common bond over watercolor paper.
8 x 10 20 minutes

10. MIXED MEDIA

Ink-line sketching can be used in combination with several other media with striking effect. However, there is one basic rule to keep in mind: Do not apply other media over a *finished* ink-line drawing. A good finished ink-line drawing has already made adjustments to represent all qualities of a subject. The application of other media is then superfluous. To be effective, ink line and other media must complement each other.

Ink Line and Pencil

Pencil is one of the most flexible of media, with a different character from that of ink line. Pencil and ink can be combined by making them complementary, either through composition or technique. Concentrated areas of ink line can be played off against larger areas of tone in pencil. Pencil technique can be altered to come closer to the high contrast quality of ink line, or ink technique can be adjusted to blend with the softer tonal quality of pencil.

Black grease pencil or Prismacolor pencil can produce a high-contrast effect that goes particularly well with ink-line sketches. A wide range of pencil materials provide a variety of expressive possibilities. Experiment with different pencils, papers, and ink.

Ink Line and Brushed Ink

Applying ink with a brush is probably the most natural, compatible extension of ink line as a medium. The brush can add a great deal of variety while maintaining the high-contrast qualities of ink line. The basic tool, a number 8, 10, or 12 pointed brush, can produce line weights varying from a fine pen line to one-quarter or one-half inch. With a brush, large areas can be quickly filled, but you should first assure yourself that the weight of the paper is sufficient to accept large amounts of ink without shrinking or warping. Like the pen a brush has a wide range of possible strokes to be explored.

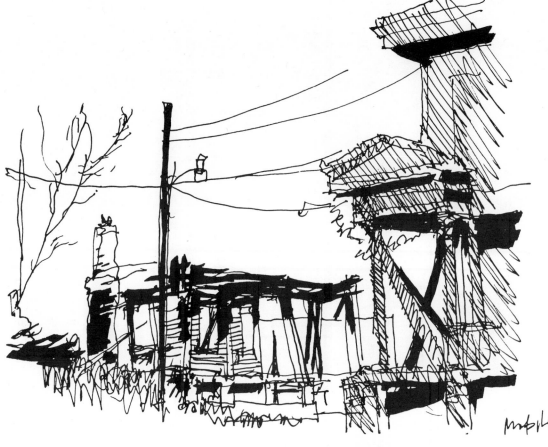

Historic preservation district, Mobile, Alabama.
Fine-line marker and wet-brushed ink.
5 x 7 20 minutes

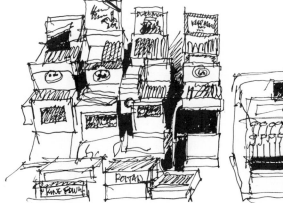

Diner, Ocean Springs, Mississippi.
Fine-line and wet-brushed ink.
5 x 7 15 minutes

Dry-brushed ink offers another range of techniques for extending the versatility of ink-line sketching. I get my best results using India or China ink and a brush with short, stiff bristles. Dry brush can quickly produce soft gradations of tone while remaining compatible with ink line.

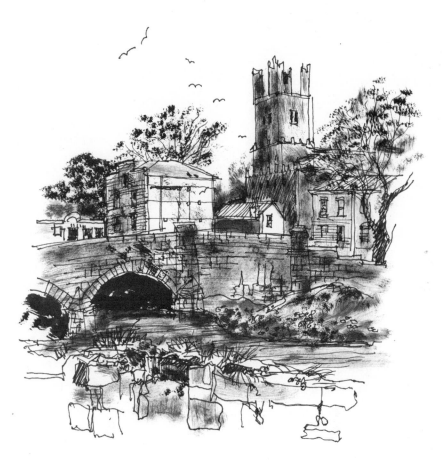

Limerick, Ireland.
Fine-line and dry-brushed ink.
8 x 10 30 minutes

Limerick, Ireland.
Fine-line and dry-brushed ink.
8 x 10 20 minutes

Ink Line and Ink Wash

Ink wash is another of the more direct extensions of ink-line sketching. Ink wash is a diluted ink normally applied with a soft brush. While effective sketches can be made by applying even wash tones, I often use erratic, uneven strokes to produce variety so as to reduce the contrast between line and wash and to add interest to the sketch. If the ink used for the line sketch reacts to water, a clear water wash can be applied with pleasing results; the water picks up and spreads some of the color from the lines. This also tends to soften the ink lines, thereby reducing the degree of contrast between wash and line work.

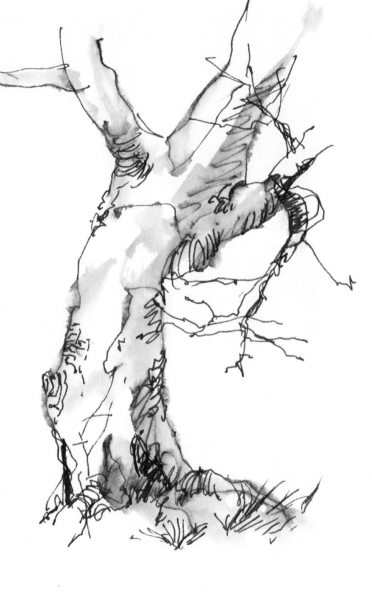

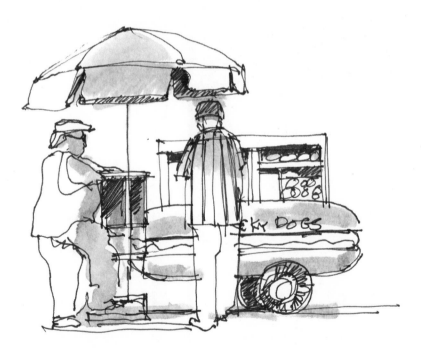

Hot dog vender, New Orleans.
Ink line and even wash.
4 x 6 10 minutes

Tree trunk.
Ink line and graduated wash.
7 x 10 10 minutes

Rivault Abbey, England.
Fountain pen and clear wash.
10 x 8 30 minutes

11. COLOR

With the use of color, one passes out of the purity of the realm of black-and-white sketches into a world of special brilliance and vitality. Color presents many new avenues of exploration and challenge. But your grounding in basic sketching will serve you well as you venture into this other world. The abilities to see, focus, represent, understand, transform, interpret, and imagine that have developed through sketching are critical to success in using color as well.

Ink Line and Color Pencil

Color pencil provides a handy portable means of incorporating color in a sketch. When traveling I usually carry a few pencils in my favorite colors and a set of colored leads and lead holder made by Pentel (these are very compact and allow me to capture a special color). As with other mixed media, color pencil and ink line should be used in a complementary way. Most of these pencils have the intensity to stand up to the high contrast of ink, but you must still be careful not to overrender in ink.

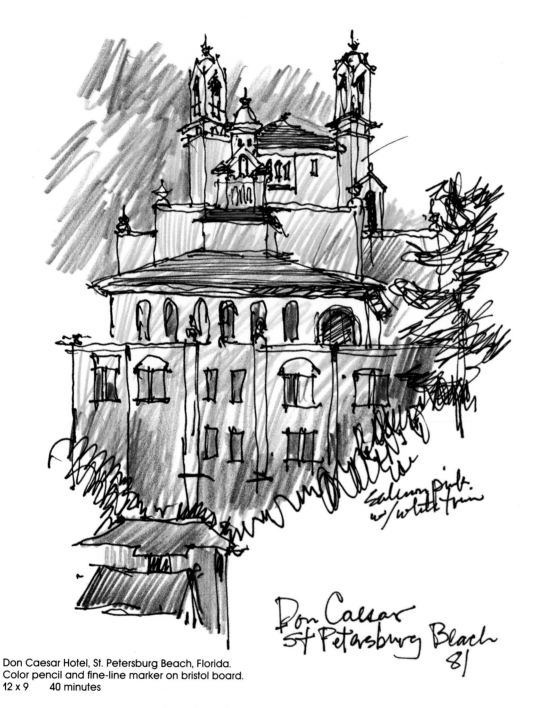

Don Caesar Hotel, St. Petersburg Beach, Florida.
Color pencil and fine-line marker on bristol board.
12 x 9 40 minutes

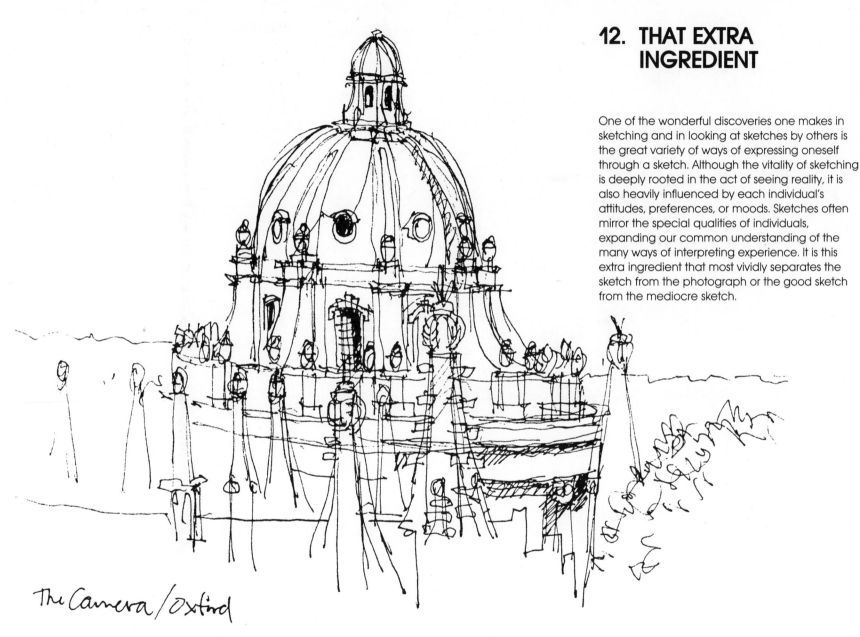

12. THAT EXTRA INGREDIENT

One of the wonderful discoveries one makes in sketching and in looking at sketches by others is the great variety of ways of expressing oneself through a sketch. Although the vitality of sketching is deeply rooted in the act of seeing reality, it is also heavily influenced by each individual's attitudes, preferences, or moods. Sketches often mirror the special qualities of individuals, expanding our common understanding of the many ways of interpreting experience. It is this extra ingredient that most vividly separates the sketch from the photograph or the good sketch from the mediocre sketch.

The Camera/Oxford

The Camera, Oxford, England.
Fine-line marker on Whatman 140# watercolor paper.
7 x 10 15 minutes

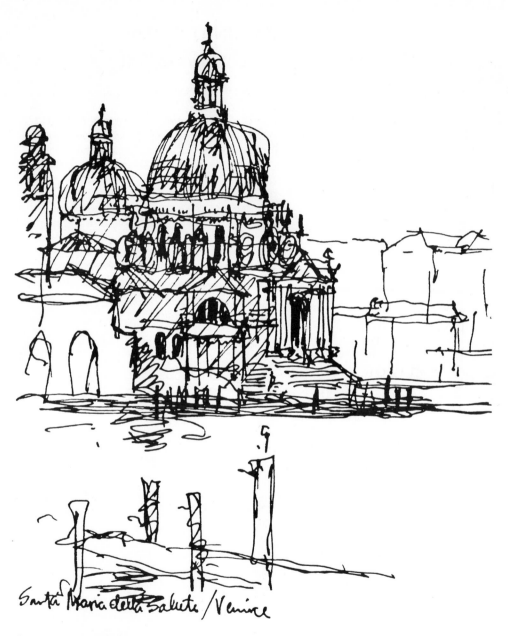

Santa Maria della Salute, Venice, Italy.
Fountain pen on Cartridge paper.
5 x 7 10 minutes

Response

For a long time I was concerned about the apparent conflict between two schools of thought about the teaching of drawing. There were those who strongly promoted a tactile, kinesthetic, reactive approach, typified by rapid sketches and moving subjects. The second approach was slowly paced, more deliberate, stressing relaxed, careful observation. Eventually I saw these two approaches as dealing with the same issue—response to the drawing subject. Both approaches sought to capture a strong reaction. This is a recognition of the source of vitality and delight in the activity and results of drawing: the unique response evoked from each of us as we encounter the world around us.

The argument about the superiority of one approach over another is foolish. If both techniques are accepted for their unique qualities, both can become part of a rich and varied repertoire of sensitivities. We do not expect that we must hate French food in order to appreciate Chinese cooking. Why should we have to choose between approaches to drawing when we have the capacity to absorb both?

Reactive Sketches

The sketches on these pages were all made very quickly, completed in two to ten minutes. Close examination of the sketches reveals little specific, detailed information about the subjects. Instead, the sketches are suggestive or evocative; they draw the viewer to participation in the act of seeing by the gaps left in the information. The message of each drawing is general and direct; its power lies in the simple way it integrates complexity to create an immediate, recognizable impression: the concentration of the person drawing; the cool shade of a church on a Venetian canal; or the relaxed calm of the bearded man.

Children on Normandy coast, France.
Medium marker on sketch paper.
9 x 6 10 minutes

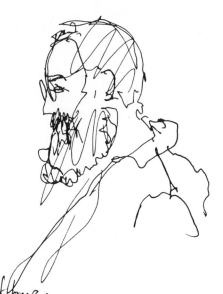

Mullins Coffee House, Covent Garden, London, England.
Fine-line marker on Strathmore 400 series sketch pad.
5 x 8 3 minutes

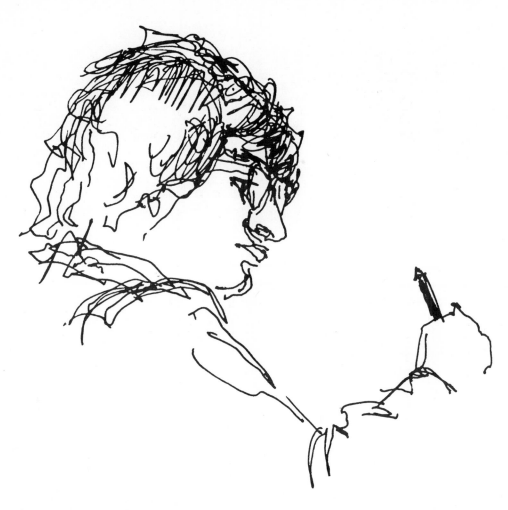

These sketches gain additional interest through the traces of a freely moving pen, which convey the mood and sensitivities of the artist. As these sketches were made, I bombarded the paper with lines and suspended all conscious judgment of the efficacy of a specific line. Looking closely at these sketches, one can find several lines that contribute little information about the subject; but there are also lines that capture or suggest important features of the subject. Take the man with the hat as an example: The lines around his chin are confusing to the point of testing credibility; but two or three lines and a couple of dots seem to have found exactly the right location to convey not only the eyes but a hint that something is going on behind the eyes. A message is also conveyed by the prevalent shape of the lines. The predominantly curvy, squiggly lines remind me of the relaxed freedom with which the sketches were done. To others they may suggest playfulness or confidence.

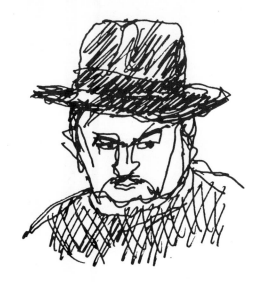

Man with hat.
Fine-line marker on Strathmore 400 series sketch pad.
3 x 3 2 minutes

Student on Sullivan urban design team.
Fountain pen on bristol board.
4 x 6 5 minutes

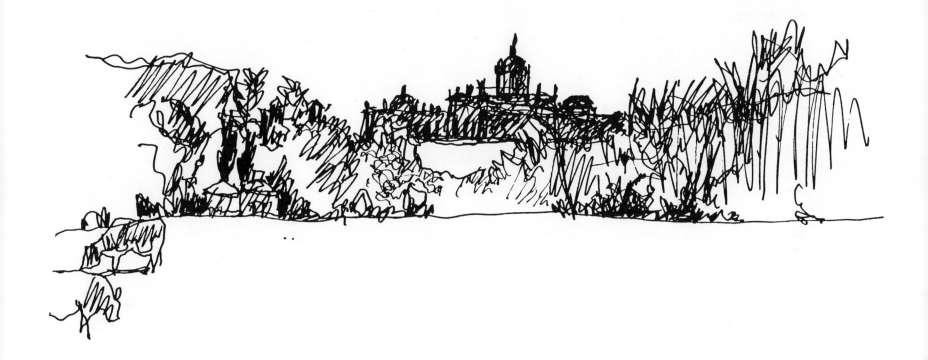

Castle Howard, Yorkshire, England.
Fountain pen on Cartridge paper.
9 x 12 20 minutes

Deliberate Sketches

Using the contrasting approach to drawing, these sketches were made at a much slower pace, taking fifteen to twenty minutes to complete. Here the carefully drawn details contribute much to the interest and quality of the sketch. Rather than being bowled over by a first impression, the viewer is drawn into the sketches by the extent and variety of detail to be discovered. Instead of the dramatic impact of an immediate, simple message, these sketches convey a sense of order and expression through the consistent and controlled use of the media.

The line work in these drawings reflects the calm, deliberate way in which they were put down. Most of my time was spent carefully looking at the subject, considering scale,

proportion, shapes, and details. Because of the complexity of the subjects, a more economical use of lines seems appropriate. After carefully viewing the subject, I was more selective about the information to be recorded. The regularity of the line work in each of these sketches approaches that of a stylized drawing, although that was not the intent. This regularity also conveys secondary messages about the perceptions or attitudes of the artist.

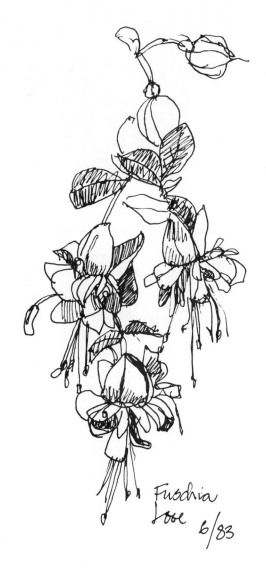

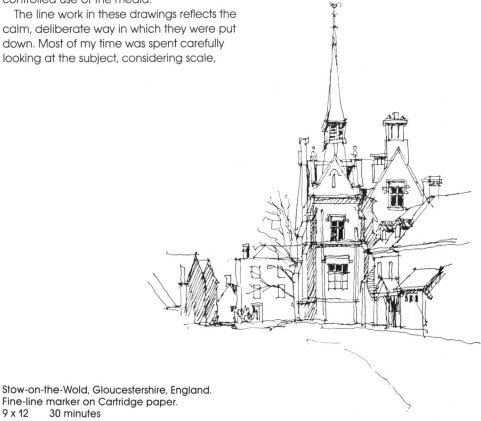

Stow-on-the-Wold, Gloucestershire, England.
Fine-line marker on Cartridge paper.
9 x 12 30 minutes

Fuschia, Looe, Cornwall, England.
Fine-line marker on Strathmore 400 series sketch pad.
5 x 8 20 minutes

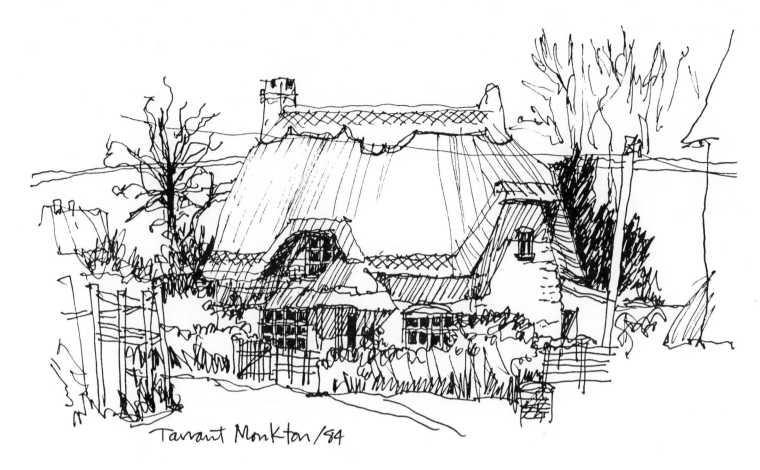

Cottage at Tarrant Monkton, Sussex, England.
Fine-line marker on Cartridge paper.
5 x 7 30 minutes

We have seen the results of two contrasting approaches to drawing. I do not believe that one is "right" and the other "wrong"; but one or the other may be more appropriate to a particular drawing subject or, equally important, to the particular artist's response to the subject. (As an aside, I try to avoid conflicts between time available and the approach taken; it can be very frustrating to try to rush a deliberate sketch of a complex subject.) Quite good results may also be had by combining two approaches in a single sketch. I began the sketch of the house with the thatched roof in a deliberate manner, carefully considering the different parts of the subject; but in rendering the thatch and the surrounding trees and bushes I moved to a looser, reactive style. To sum up, when it comes to technique, you should be fully aware of the extremes. You should be careful not to choose sides but to extend the versatility and richness of your sketching skills.

Expression

At times a sketch subject acts as a stimulus, bringing forward personal feelings or biases. The time of day, what I had for breakfast, how I feel about myself, or a particular type pen and paper may also be a stimulus. Some of my most enjoyable or successful sketches resulted from freely responding to the moment and allowing myself to respond naturally to those feelings. The sketch made in rue St. Antoine seems to capture my feeling of enjoyment of the old buildings, shops, and people at morning market time. Upon close examination, it is difficult to attribute the overall feeling of the sketch to specific lines; it is even difficult to determine exactly what specific lines represent. For me this is one of those cases where the whole means much more than the sum of the parts. The more angular, taut character of the lines in the sketch of the tree at Carmel Beach expresses my empathy for the struggle made by the tree to survive in the strong coastal winds and the eroding shore of the Pacific.

Rue St. Antoine, Paris, France.
Fountain pen on Cartridge paper.
5 x 7 10 minutes

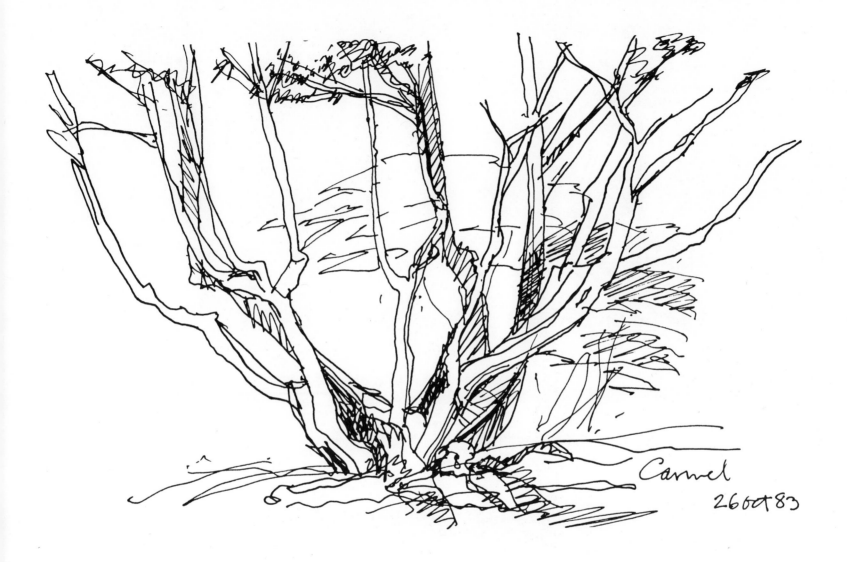

Beach at Carmel, California.
Fine-line marker on Strathmore 400 series sketch pad.
5 x 8 10 minutes

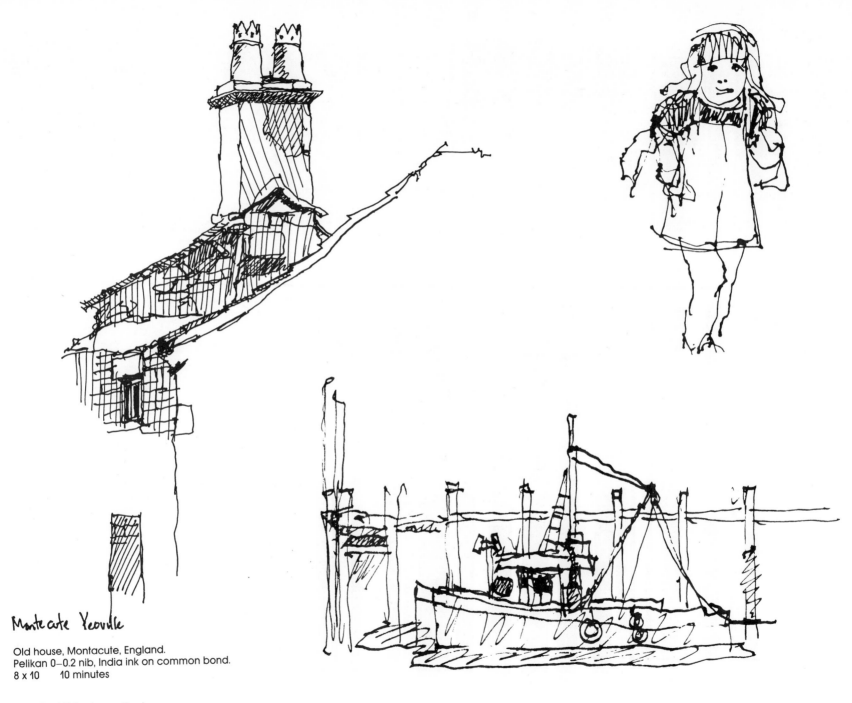

Montacute Yeovile

Old house, Montacute, England.
Pelikan 0—0.2 nib, India ink on common bond.
8 x 10 10 minutes

Economy

Sketches can derive a special quality from the economy with which they communicate. I enjoy the sketches on these pages because of the degree of sensation they create with limited means. Granted that part of my enjoyment stems from my direct experience with the subjects, nevertheless some of this sensation is probably communicated to others as well. Much inspiration for economy in sketching can be found in the work of cartoonists such as those who work for *The New Yorker* magazine or syndicated political cartoons. Pfeiffer, Oliphant, Searle, Saxon, and Rowland Wilson are among my favorites. Their work reflects a thorough understanding of their subjects, which allows them the freedom to suggest rather than tediously detail their message and still achieve great impact.

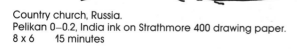

Country church, Russia.
Pelikan 0–0.2, India ink on Strathmore 400 drawing paper.
8 x 6 15 minutes

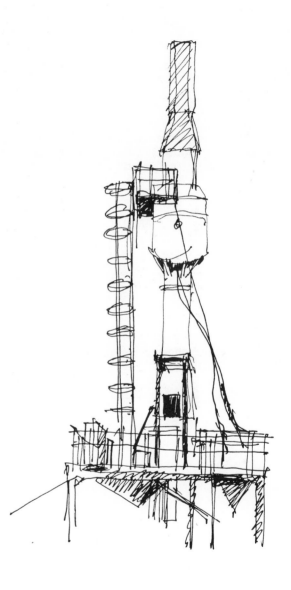

Foundry, Poole, England.
Fine-line marker on Cartridge paper.
6 x 8 15 minutes

Energy

Sometimes sketches can be impressive by the evidence they show of the energy or vitality of the person who made them. Both of the sketches on these pages were done rapidly with a great deal of enthusiasm. Being fairly complicated, the subjects could have been overwhelming. However, they provoked such interest that I just plunged in and flailed around with high hopes.

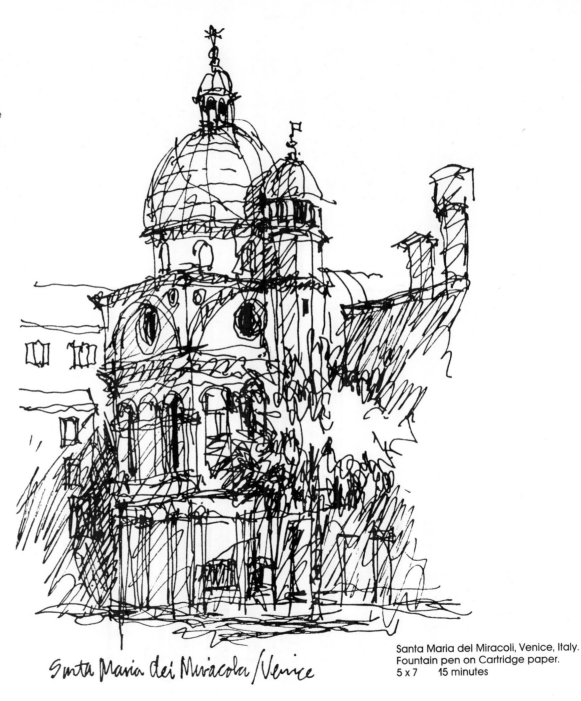

Santa Maria dei Miracola / Venice

Santa Maria del Miracoli, Venice, Italy.
Fountain pen on Cartridge paper.
5 x 7 15 minutes

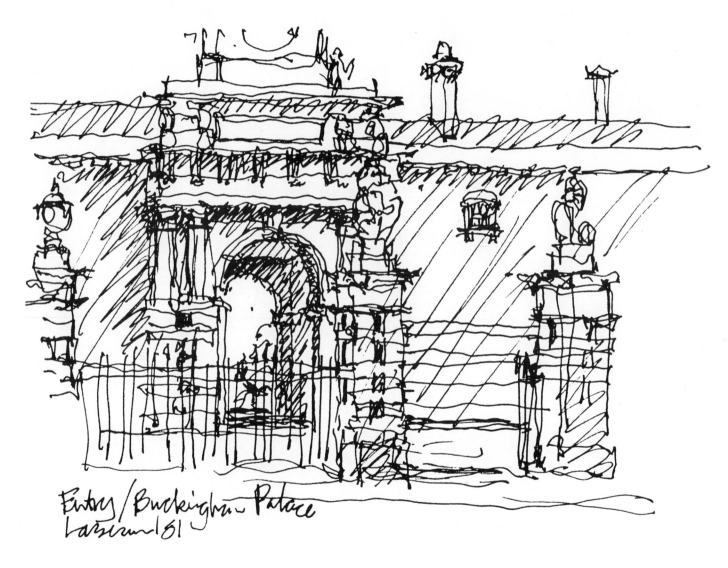

Entry, Buckingham Palace, London, England.
Fountain pen on Cartridge paper.
5 x 7 15 minutes

Mood

A sketch may also reflect a strong mood evoked by the subject. In both the sketch of the castle at Dieppe and the church in Lackawanna, the mood is somber, even threatening. In an unplanned, gut-level response, this mood was conveyed by the violent or tortured line strokes and the large areas of dark tone.

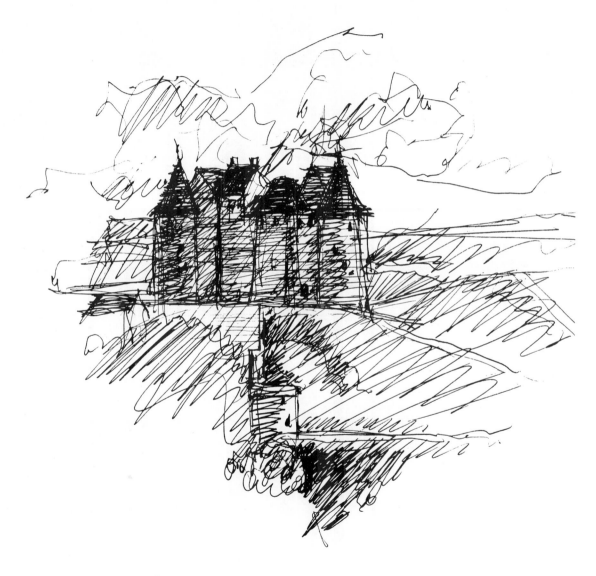

Dieppe, Normandy coast, France.
Fine-line marker on common bond.
10 x 8 15 minutes

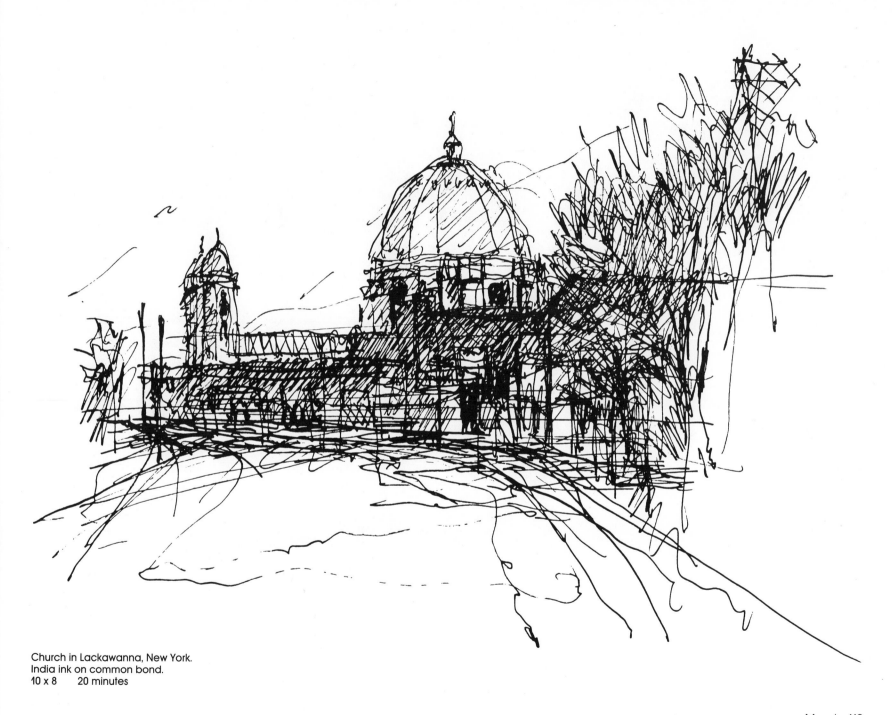

Church in Lackawanna, New York.
India ink on common bond.
10 x 8 20 minutes

In contrast to some of the previous sketches, these from Paris and the west coast of Sweden are rather calm and restful. In both instances, I took my time, almost methodically recording as I visually absorbed the scene. Part of learning to sketch is developing the knack of sensing the stimulus of the subject and your own feelings and letting them lead you in your work rather than struggling with preconceived plans or expectations.

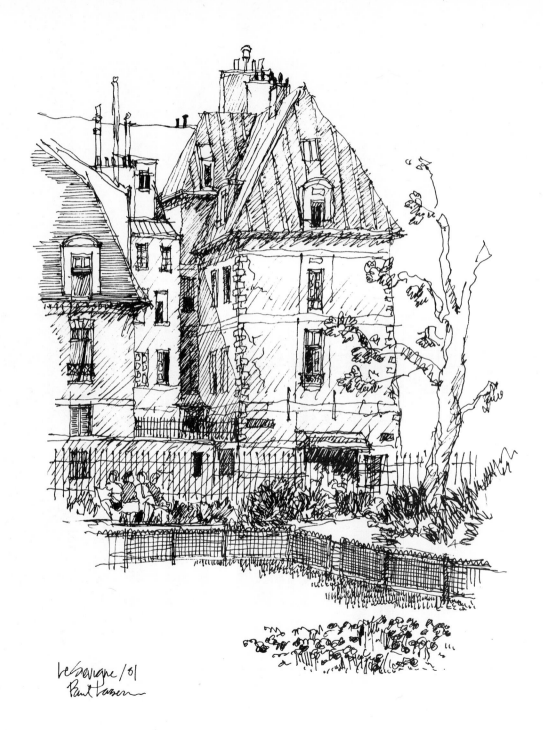

Le Sevigne Hotel, Marais district, Paris, France.
Fine-line marker on Morilla all-purpose sketch paper.
14 x 17 35 minutes

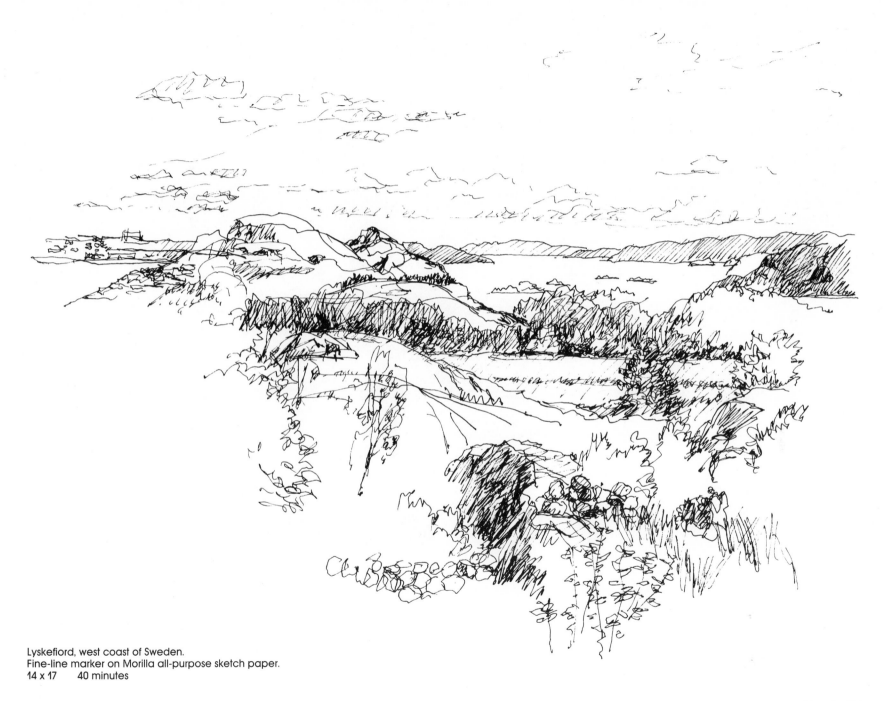

Lyskefiord, west coast of Sweden.
Fine-line marker on Morilla all-purpose sketch paper.
14 x 17 40 minutes

Touch

As you experiment with different pens and papers, favorite combinations of media and technique will emerge. Some subjects present an opportunity to exploit your sensitivity to a particular pen moving over a particular type of surface. One of my favorite tactile sensations is that of a fine-line marker on Cartridge paper. With a light touch the pen can almost skate across the surface, leaving delicate traces of motion. The trees in the village at Castle Corfe and the secluded site of an antebellum home were able to make good use of this special quality.

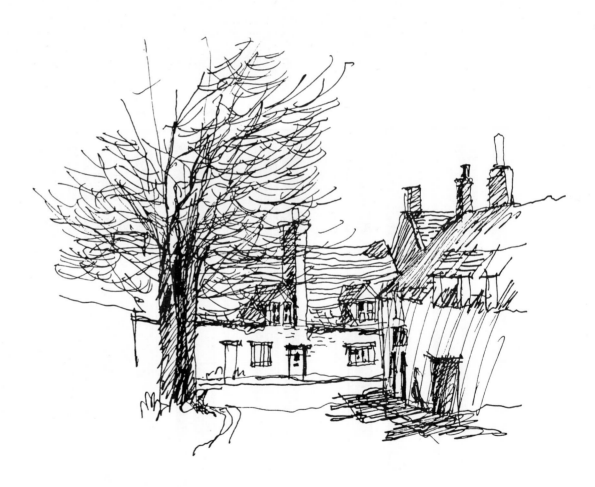

Village near Castle Corfe, Dorset, England.
Fine-line marker on Cartridge paper.
6 x 8 10 minutes

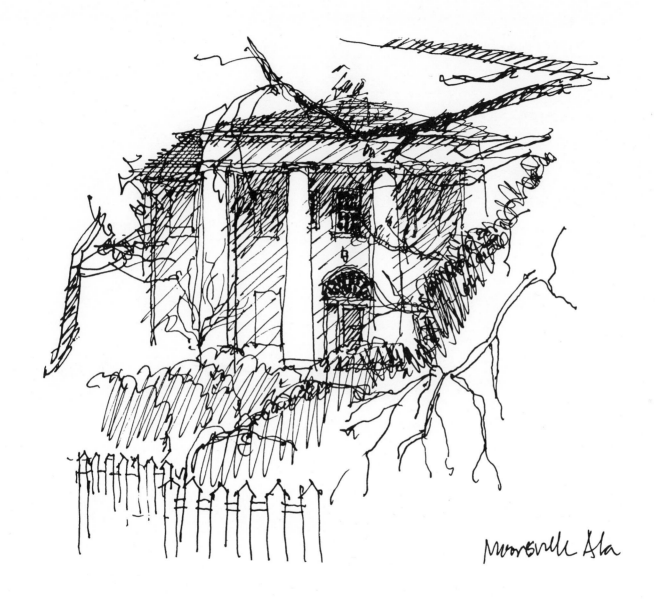

Moorsville Ala

Antebellum House, Mooresville, Alabama.
Fine-line marker on Cartridge paper.
8 x 6 15 minutes

wood shingles

peagreen except for cream post

several people on porch

Hopkins House / Pensacola

stone base

typical balister

Hopkins House, Pensacola, Florida.
Fine-line marker on common bond.
7 x 5 10 minutes

125

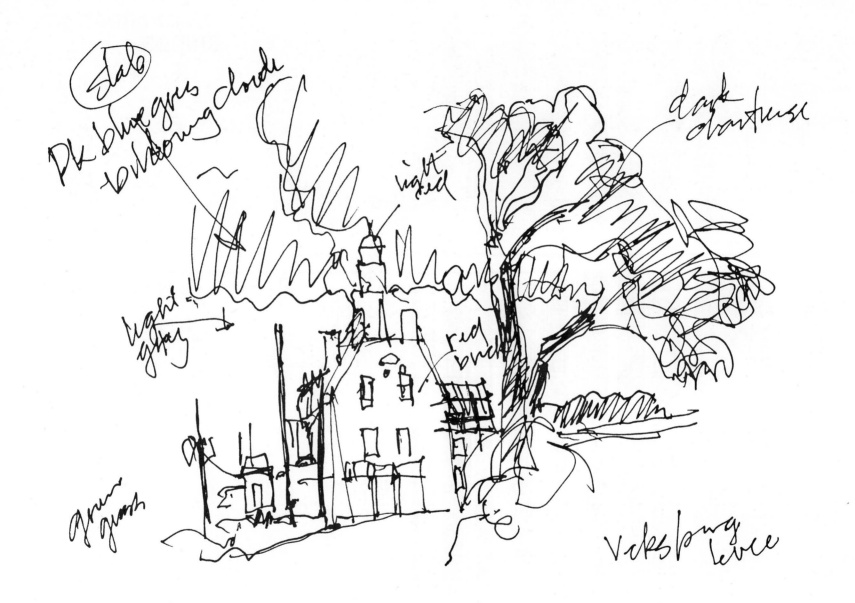

Railroad station at the levee, Vicksburg, Mississippi.
Fine-line marker on common bond.
7 x 5 5 minutes

126 Demonstrations: Studies

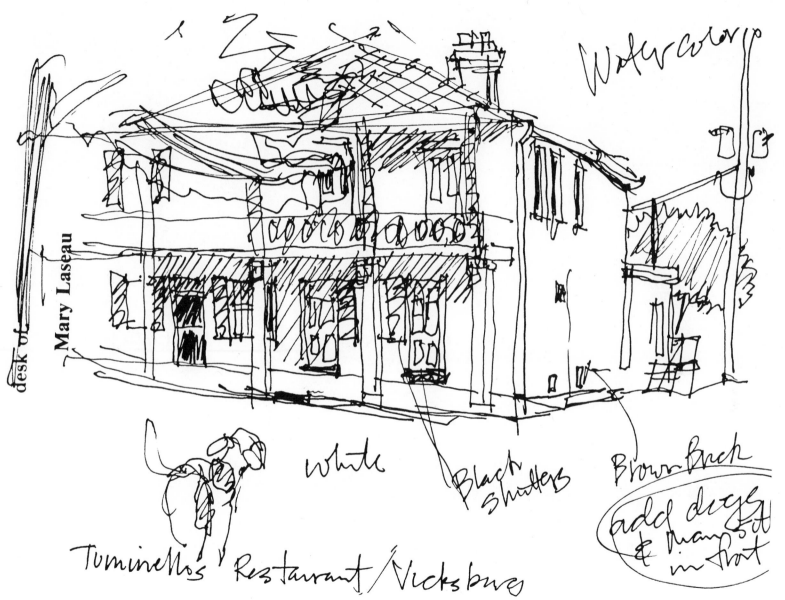

Watercolor

desk of **Mary Laseau**

white Black Shutters Brown Brick

add drugs & many ST in front

Tuminellos Restaurant/Vicksburg

Tuminello's Restaurant, Vicksburg, Mississippi.
Fine-line marker on common bond.
7 x 5 10 minutes

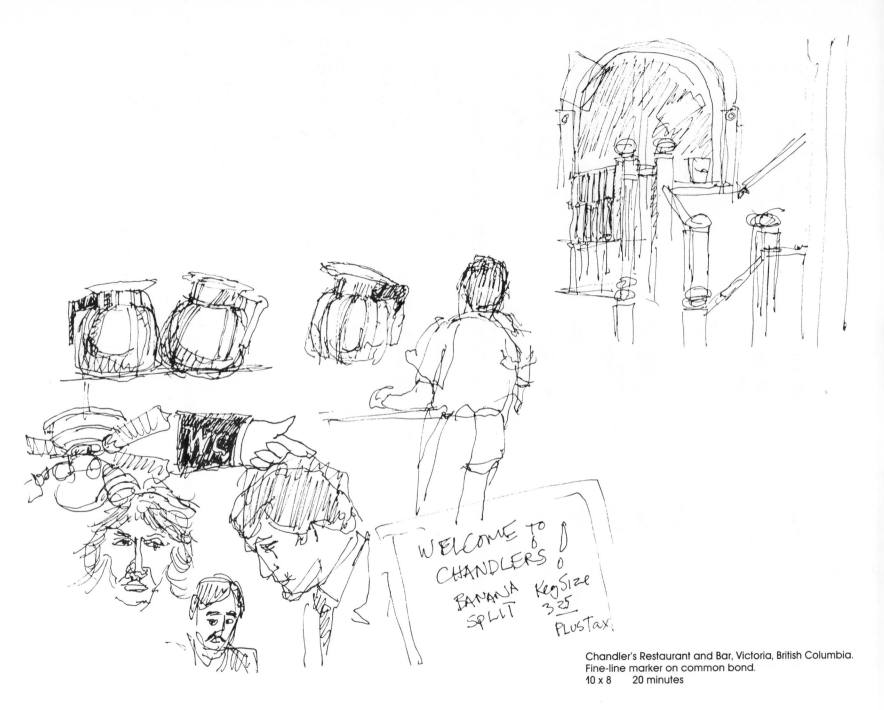

WELCOME TO
CHANDLERS!
BANANA KegSize
SPLIT 3 25
PLUS TAX

Chandler's Restaurant and Bar, Victoria, British Columbia.
Fine-line marker on common bond.
10 x 8 20 minutes

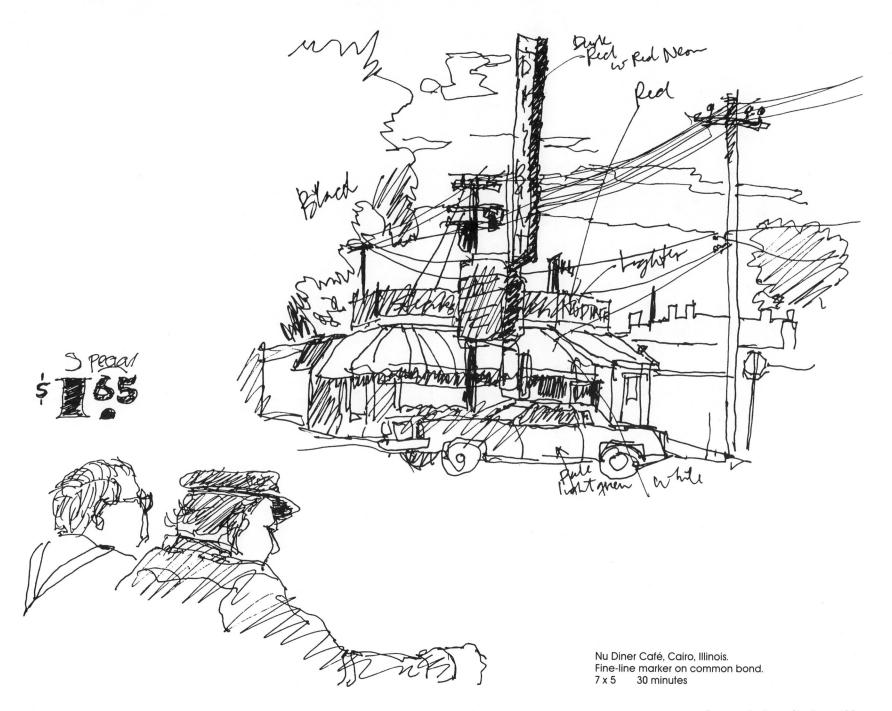

Dark
Red w Red Neon

Red

Black

lighter

S pecial
$165

Nu Diner Café, Cairo, Illinois.
Fine-line marker on common bond.
7 x 5 30 minutes

Oak Alley Plantation, Louisiana.
Fine-line marker on common bond.
7 x 5 10 minutes

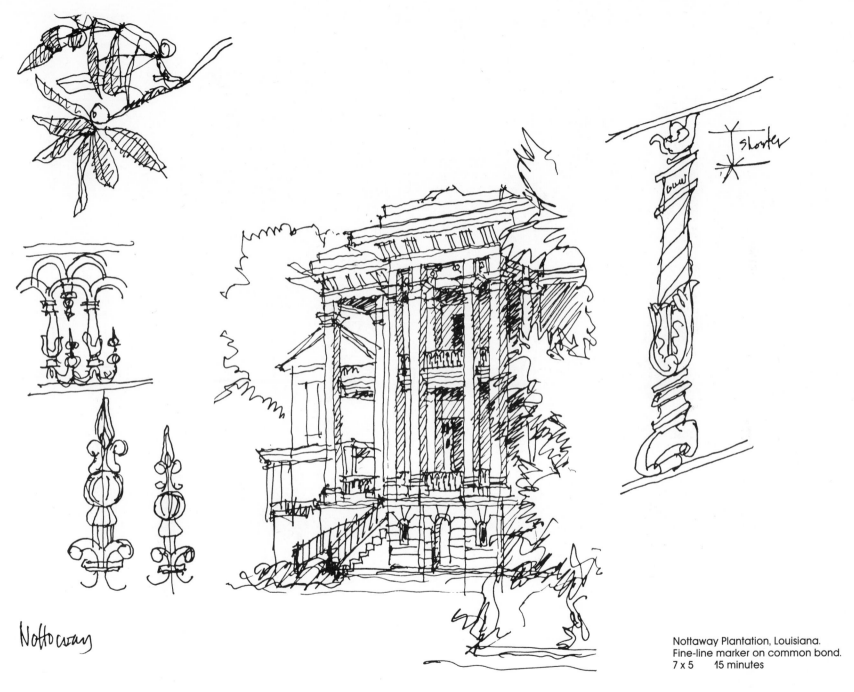

Nottaway

shorter

Nottaway Plantation, Louisiana.
Fine-line marker on common bond.
7 x 5 15 minutes

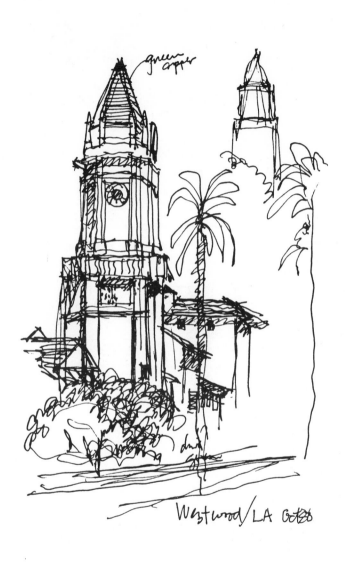

green copper

Westwood/LA Oct 80

Westwood district, Los Angeles.
Fine-line marker on Strathmore sketch paper.
5 x 7 30 minutes

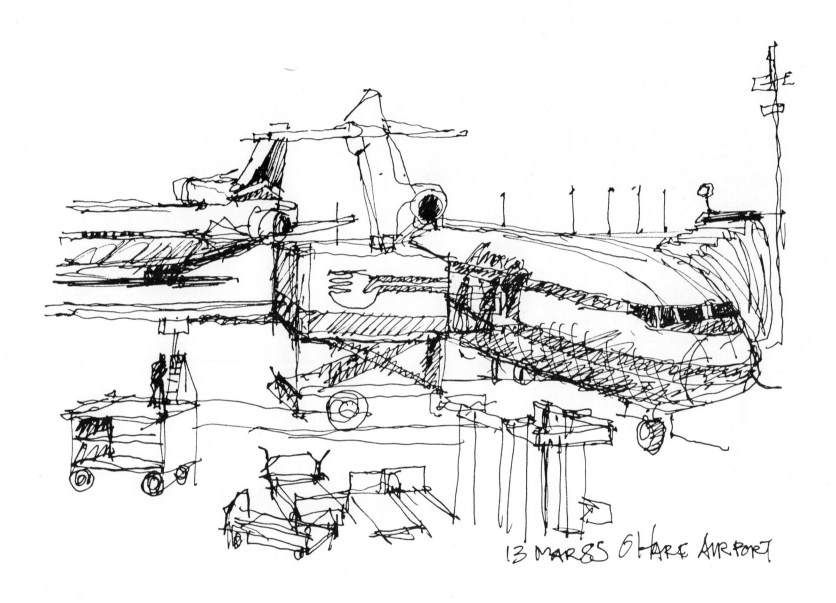

13 MAR 85 O'HARE AIRPORT

O'Hare Airport, Chicago, Illinois.
Fine-line marker on Cartridge paper.
7 x 5 15 minutes

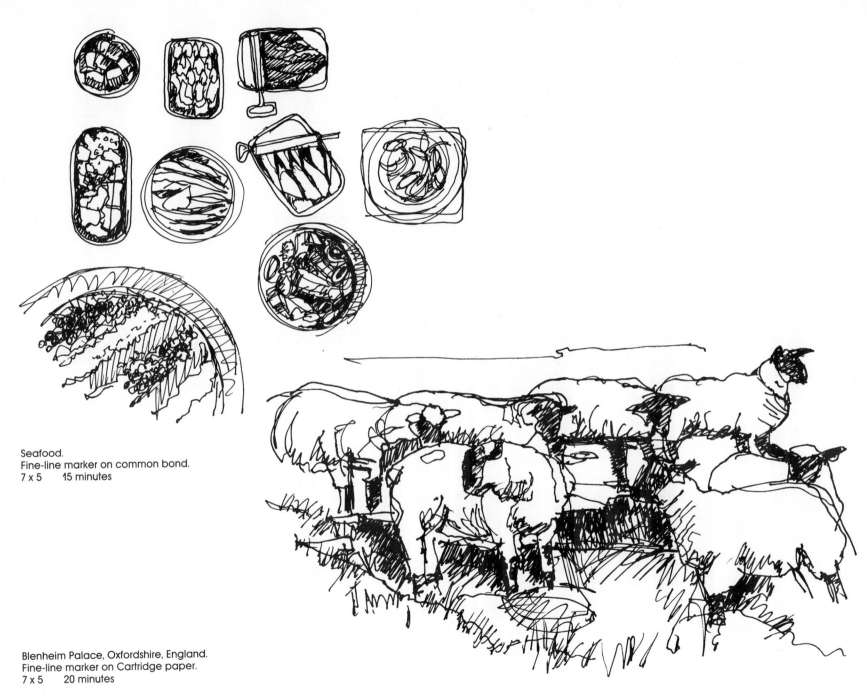

Seafood.
Fine-line marker on common bond.
7 x 5 15 minutes

Blenheim Palace, Oxfordshire, England.
Fine-line marker on Cartridge paper.
7 x 5 20 minutes

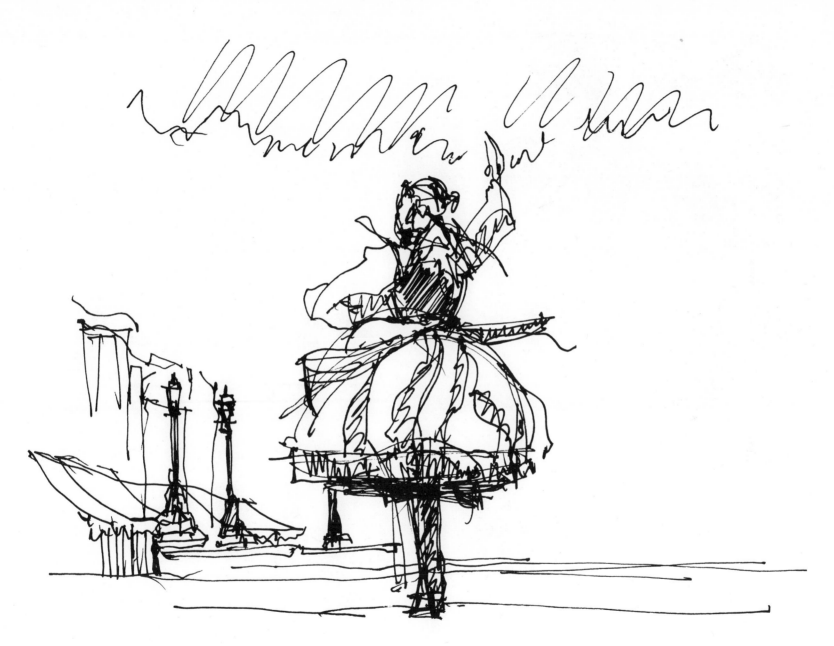

Fête de Pont Neuf, Paris, France.
Fine-line marker on Cartridge paper.
7 x 5 10 minutes

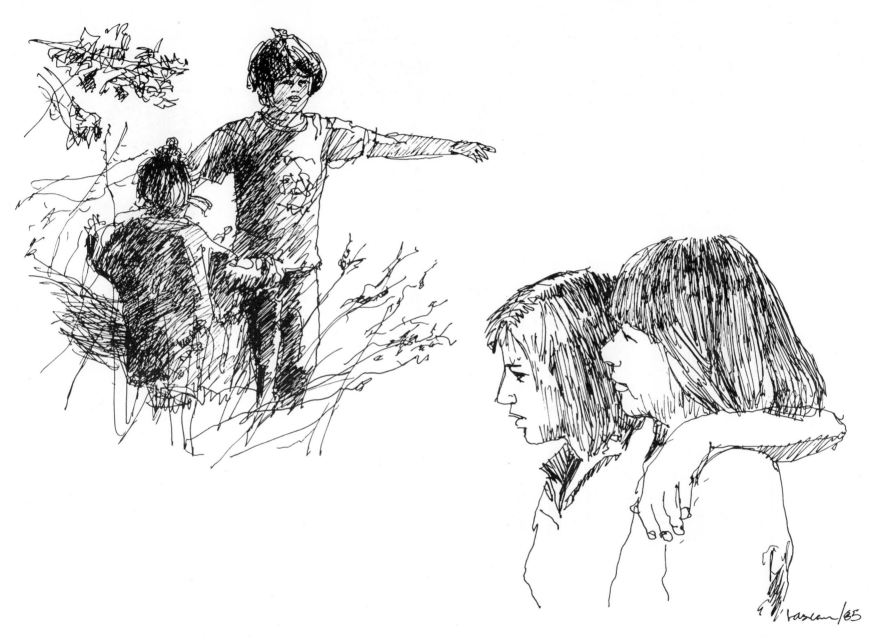

Sketch studies, Laseau family.
Osmiroid Rolatip Extra Fine nib on 1-ply bristol board.

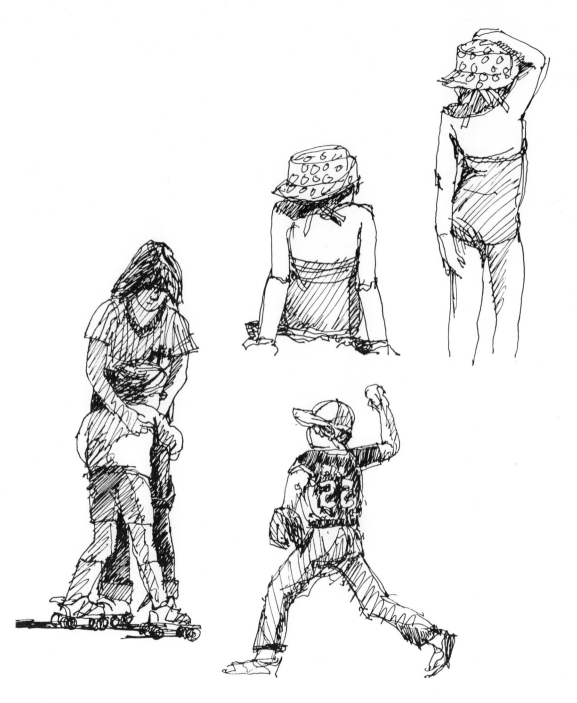
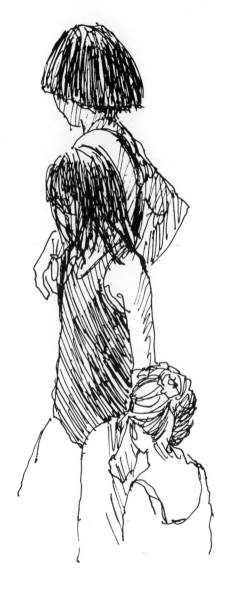

Sketch studies, Laseau family.
Osmiroid Rolatip Extra Fine nib on 1-ply bristol board.
8 x 10 3–10 minutes each

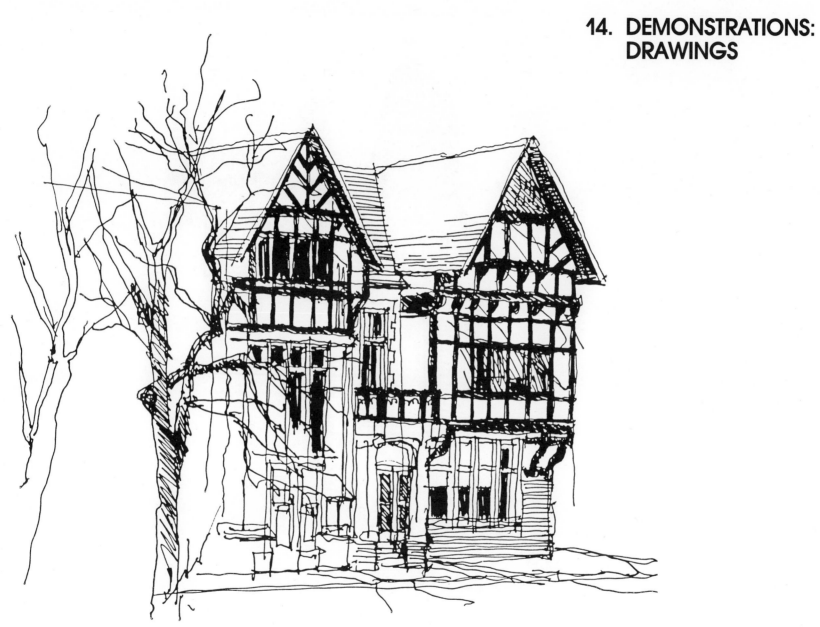

Town center, Salisbury, England.
Fine-line marker on Cartridge paper.
9 x 12 25 minutes

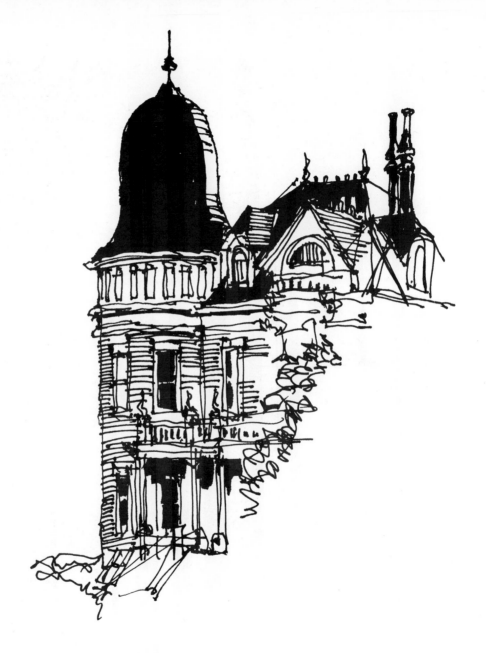

Montgomery/85

Montgomery, Alabama.
Fine-line and broad calligraphy markers.
8 x 10 20 minutes

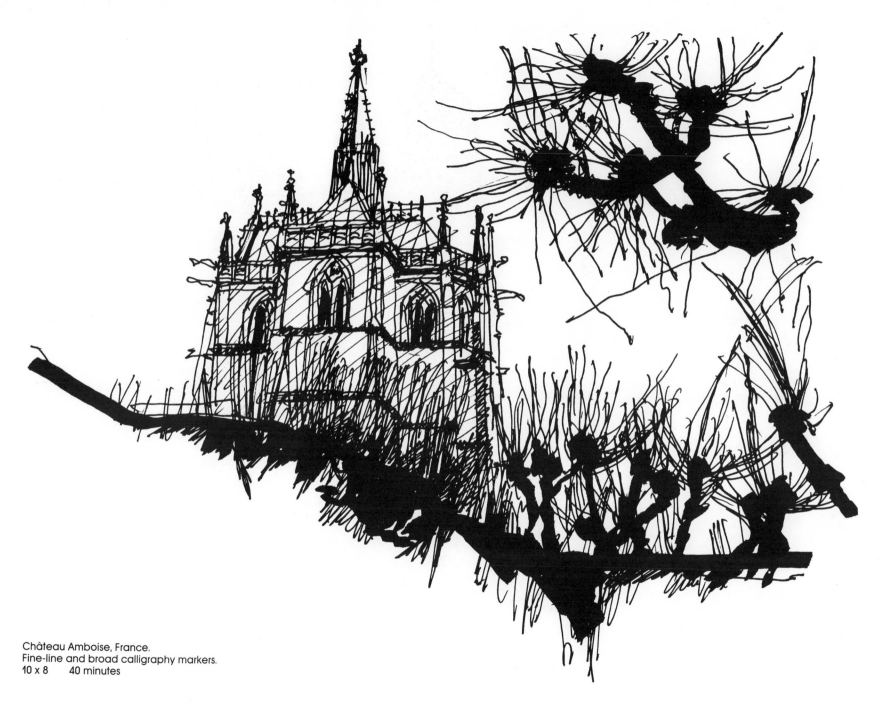

Château Amboise, France.
Fine-line and broad calligraphy markers.
10 x 8 40 minutes

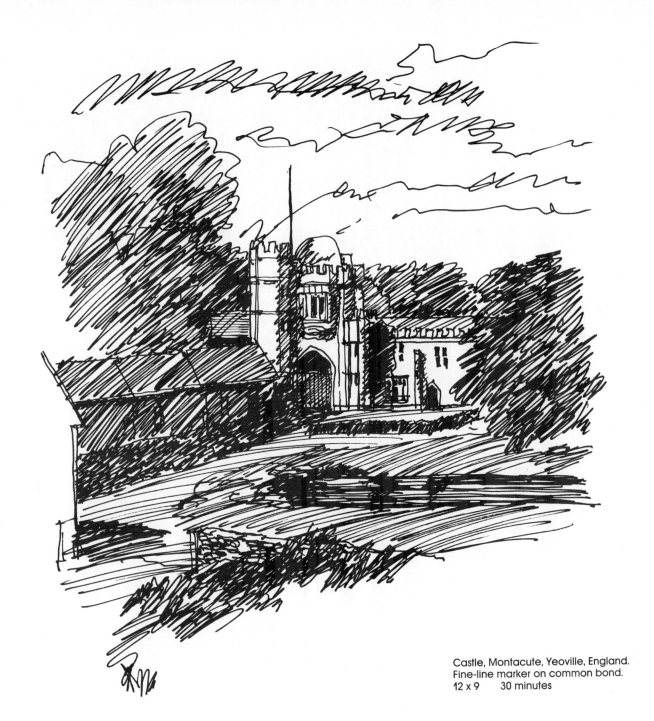

Castle, Montacute, Yeoville, England.
Fine-line marker on common bond.
12 x 9 30 minutes

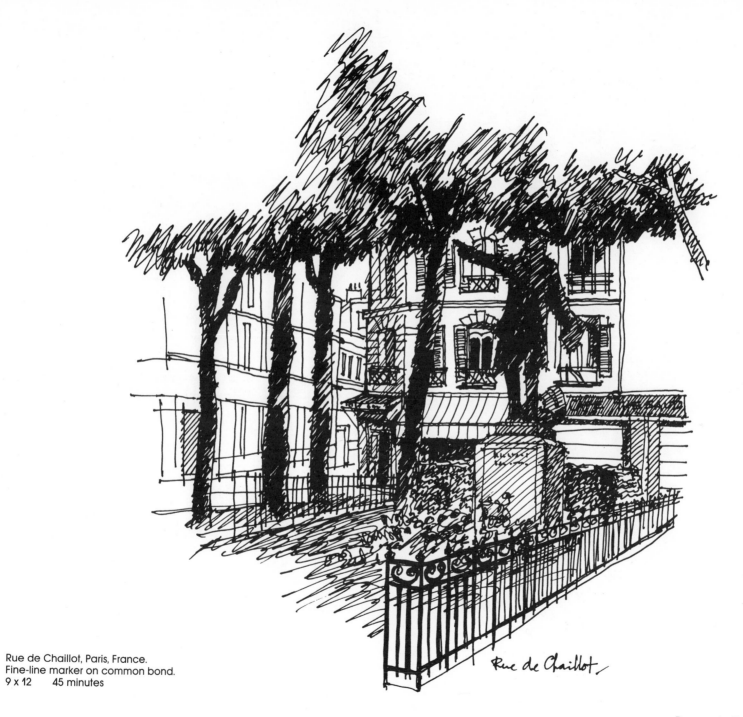

Rue de Chaillot, Paris, France.
Fine-line marker on common bond.
9 x 12 45 minutes

Rue de Chaillot

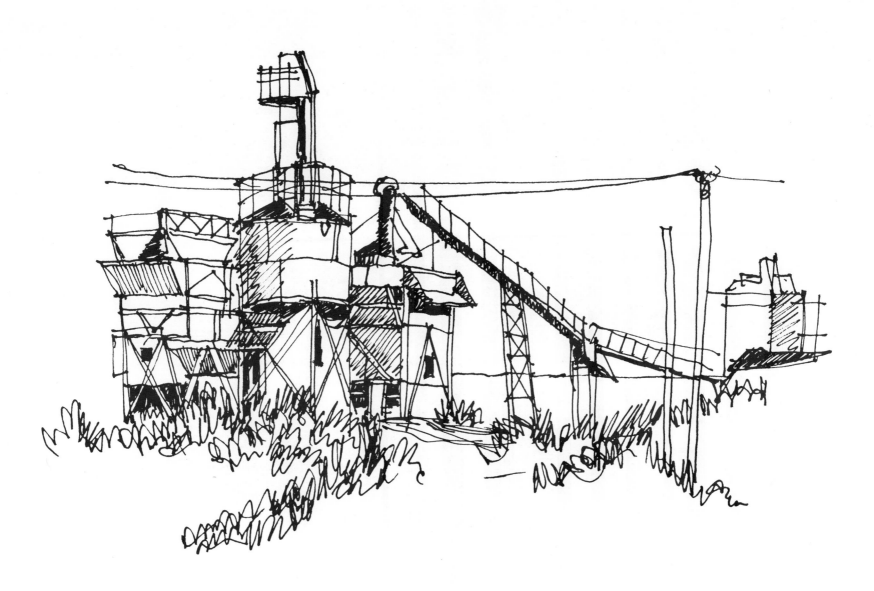

Harbor, Mobile, Alabama.
Fine-line marker on common bond.
8 x 6 20 minutes

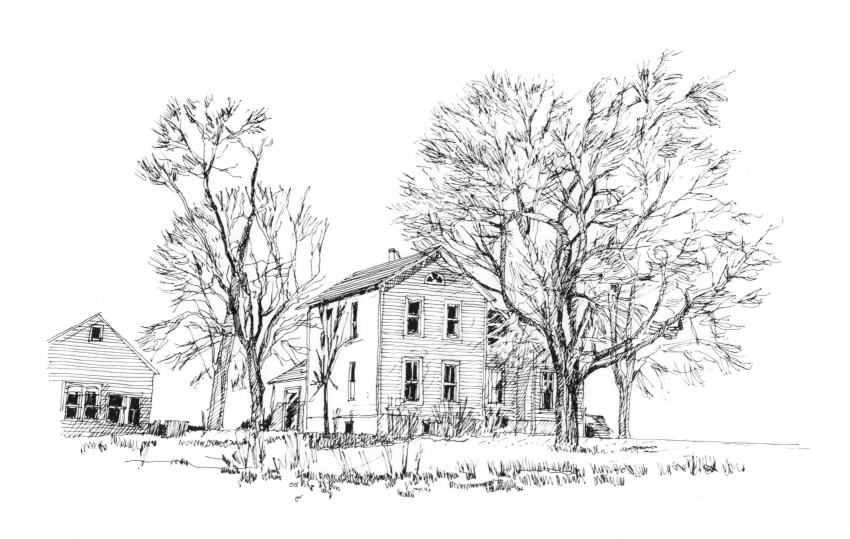

Illinois farmhouse.
Fine-line marker on Strathmore 400 series drawing paper.
14 x 22 50 minutes

Salzburg, Austria.
Fountain pen on common bond.
6 x 9 15 minutes

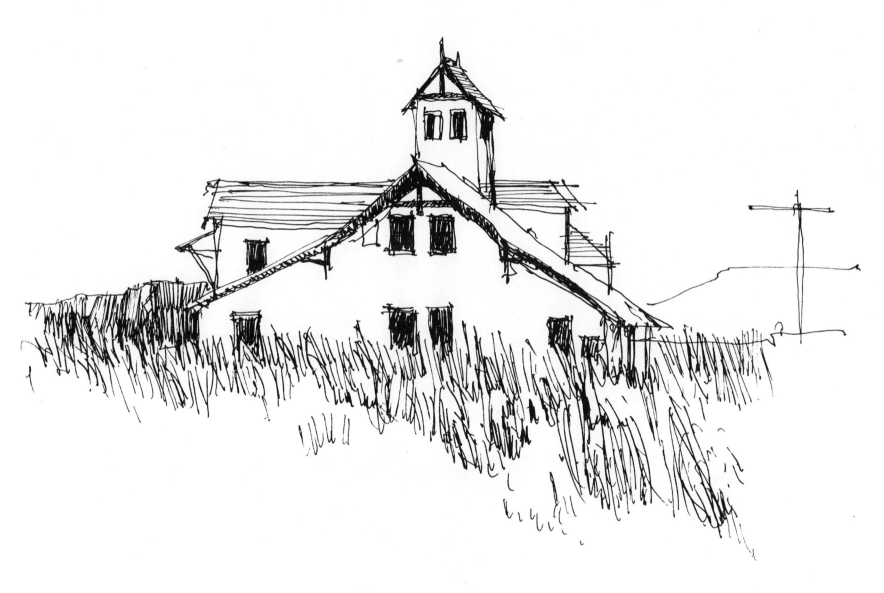

Ohio Valley barn.
Osmiroid Extra Fine nib on common bond.
10 x 8 20 minutes

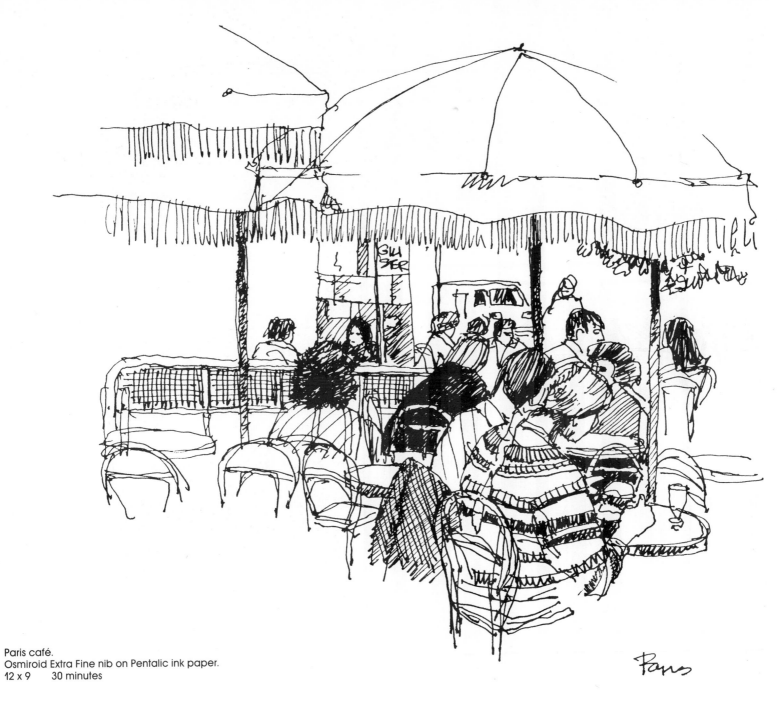

Paris café.
Osmiroid Extra Fine nib on Pentalic ink paper.
12 x 9 30 minutes

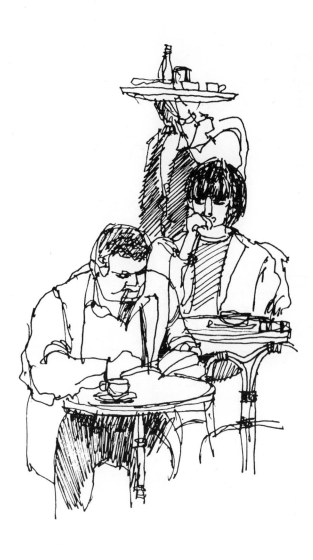

Paris café
Osmiroid Extra Fine nib on 1-ply bristol board.
6 x 8 15 minutes

Café, Place des Vosges, Paris, France.
Osmiroid Extra Fine nib on 1-ply bristol board.
8 x 10 20 minutes

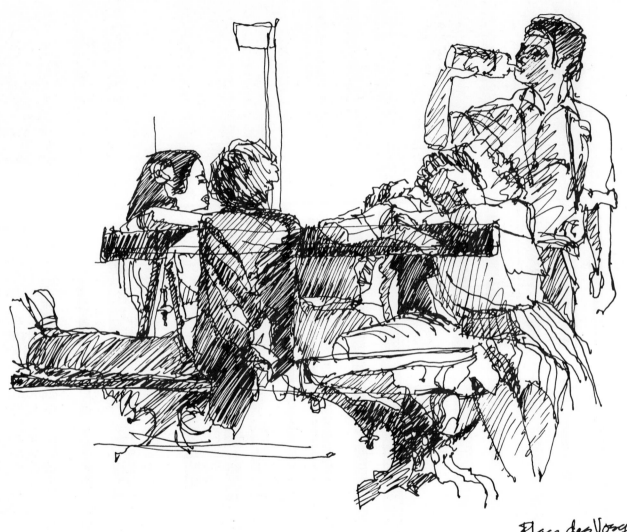

Place des Vosges

Place des Vosges, Paris, France.
Osmiroid Extra Fine nib on 1-ply bristol board.
10 x 8 50 minutes

BIBLIOGRAPHY

Billcliffe, Roger. *Architectural Sketches and Flowers: Drawings by Charles Rennie Mackintosh.* New York: Rizzoli Publications, Inc., 1977.

Borgman, Harry. *Drawing with Ink.* New York: Watson-Guptill Publications, 1977.

Ching, Frank. *Architectural Graphics.* 2nd ed. New York: Van Nostrand Reinhold Company, 1985.

Czaja, Michael. *Freehand Drawing: Language of Design.* Walnut Creek, CA: Gambol Press, 1975.

Dondis, D. A. *A Primer of Visual Literacy.* Cambridge, MA: The MIT Press, 1973.

Downer, Richard. *Drawing Buildings.* New York: Watson-Guptill Publications, 1962.

Doyle, Michael. *Color Drawing.* New York: Van Nostrand Reinhold Company, 1980.

Edwards, Betty. *Drawing on the Right Side of the Brain.* Los Angeles: J. P. Tarcher, Inc., 1979.

Evans, Ray. *Drawing and Painting Architecture.* New York: Van Nostrand Reinhold Company, 1983.

Goldstein, Nathan. *The Art of Responsive Drawing.* Englewood Cliffs, NJ: Prentice-Hall, Inc., 1973.

Gombrich, E. H. *The Sense of Order.* Ithaca, NY: Cornell University Press, 1979.

Hanks, Kurt and Larry Belliston. *Draw! A Visual Approach to Thinking, Learning, and Communicating.* Los Altos, CA: William Kaufmann, Inc., 1977.

Hogarth, Paul. *Drawing Architecture.* New York: Watson-Guptill Publications, Inc., 1973.

Hogarth, Paul, and Stephen Spender. *America Observed.* New York: Clarkson N. Potter, Inc., 1979.

Huxley, A. *The Art of Seeing.* Seattle: Madrona Publishers, 1975.

Lockard, William Kirby. *Design Drawing.* Rev. ed. Tucson: Pepper Publishing, 1982.

McGinty, Tim. *Drawing Skills in Architecture.* Dubuque, Iowa: Kendall/Hunt Publishing Co., 1976.

McKim, Robert H. *Experiences in Visual Thinking.* Monterey, CA: Brooks/Cole, 1972.

Meglin, Nick. *On-the-Spot Drawing.* New York: Watson-Guptill Publications, 1968.

Millard, David Lyle. *More Joy of Watercolor.* New York: Watson-Guptill Publications, 1984.

The Notebooks of Paul Klee. Vol. 1: The Thinking Eye. New York: Wittenborn, 1978.

Shook, Georg and Gary Witt. *Sharp Focus Watercolor Painting.* New York: Watson-Guptill Publications, 1981.

Simpson, Ian. *Drawing: Seeing and Observation.* New York: Van Nostrand Reinhold Company, 1973.

Stave, Thomas. *Spokane Sketchbook.* Seattle: University of Washington Press, 1974.

Steinberg, Saul. *The Passport.* New York: Random House, 1979.

Thiel, Phillip. *Freehand Drawing: A Primer.* Seattle: University of Washington Press, 1965.

Welling, Richard. *Drawing with Markers.* New York: Watson-Guptill Publications, 1974.

INDEX